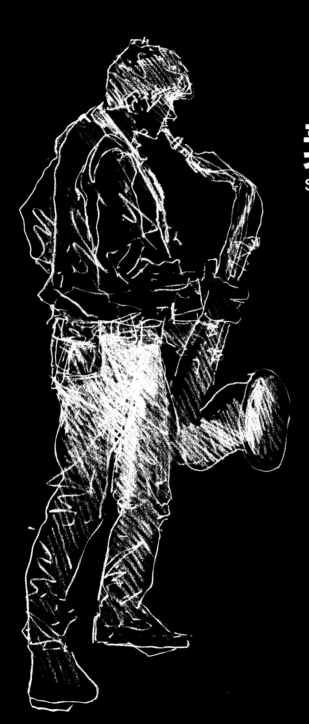

孫少英的

素描趣味
Sketching Delights

詩興的抒寫 意趣的結晶

藝術評論家 **吳越**

人們普遍有一個誤解；以為「素描」（sketch）僅是西畫入門的一項功課；事實上素描自14世紀末，已經成為一門獨立的藝術—它不但已與油畫、水彩、粉畫、版畫等地位並列；同樣的它有著廣泛的表現領域：體積、空間、深度、色階和質地。是以素描早已躍升為代表一個藝術家具有創作能力的藝術品；文藝復興期三大巨擘之一的米開朗基羅（B. Michlamgelo）曾以他的素描作為餽贈的高貴禮品。

從14世紀末以降，迄今7個世紀以來，素描的地位愈益顯著，早在19世紀中葉，執後期印象派及野獸派牛耳的法國大畫家馬諦斯（H. Matisse）即認為；以線條為主軸的素描，是傳達情感最純粹的方法，他說：「速寫（素描的別稱）有如光的發電機；它含有飽和的情感，和豐沛的趣味。」

我們回顧中國藝壇，對素描也有若合符節的評價；30年代中國美術評論家宗白華，對素描即有一段中肯的品評：

西洋繪畫的素描與中國畫的白描，擺脫了色彩的紛華與燦爛，輕裝簡從，直接把物象的輪廓、動態、靈魂；畫家的眼、手、心與造物面對面的肉搏—物象在素描下啟示了它的真形，畫家在此流露了他的手法與不同的個性。

今（2015）年元月中旬，接得少英兄寄來「墨花香」在台北禾碩建築展出畫作的請束；進到展場，使我驚艷的是所有的展出作品，都是「墨分五彩」墨香絪蘊、墨光映射的素描；這一系列作品描繪的景物，涵蓋著台北市羅斯福路、青田街、同安街、浦城街等地區，這一名聲鼎著的文教中心，重要的景點如：椰樹森列的台大校門、椰林大道、紀念教育界前輩傅斯年先生的「傅鐘」、林木翁鬱的師大校園、沈靜幽雅的青田76號、蘊穆樸素的紀州庵文學森林館…這批描繪得淋漓盡致的素描，它傳遞給觀者的信息，有如好友重逢的感覺；讓人再一次品味到這些景物中，每一棟承載著歲月風霜的建築，經歷過時光催化而枝柯垂邁的樹木、點綴著建物門面的一些年塵斑駁的陳設…這些雖只是兩度空間的描繪，它卻在少英兄筆觸揮灑下，讓人進入深度的時光隧道；深深地感觸，餘味無窮的咀嚼；這對久居台北的我而言，不啻是一次藝術的饗宴。

和少英兄知交，屈指已經超過半個世紀了，十分有緣的是1970年代，少英兄服務于台灣電視公司，任美術指導。筆者步踵其後，卻服于中華電視公司，任美術指導。之後少英兄升任台視美術組長，筆者亦有幸被擢升為華視美術組長。在那個老三台（台視、華視、中視）雄霸台灣影視市場的年代，公司之間的競爭勢同水火，但筆者與少英兄之間的私誼，卻始終保持著彼此尊敬和互相勉勵的溫馨境界。還記得那些年，華視製作連續劇「包青天」，每天有六個劇組緊迫趕錄進

度，不巧華視當時又值改建老舊建物，影棚嚴重失調，爲免節目「開天窗」，遂到處懇求需索；還是得少英兄的力助和引介，才租借到光啓社的影棚，解了燃眉之急。

　　1991年少英兄退休，移居埔里。我于1995年退休後遠颺美國賦閒；我們雖然彼此重陽遠隔，却偶有信息往還。當1991年少英兄由台北蟄居中部埔里鄉村時，人們多以爲他要效法唐代詩人王維，作終南隱士哩，而少英兄却是爲了更專心致志於繪畫才決心遠避都市塵囂，這正如西方諺語所謂：沈潛是爲了躍起。

　　當1999年九二一中部大地震爆發，埔里正是重災區；少英兄不避艱險和危夷，在災區完成了百餘幅災難素描（畫作捐贈台大圖書館典藏）。這一忘我的舉措，展現了他那藝術家悲憫的另一個面貌，更突顯了他對藝術表現鍥而不捨的追求精神。2011年筆者歸國後，與少英兄重敘友誼，並時常讀到他的大作，他對藝術的執著和熱忱讓筆者由衷地敬佩。

　　記得同是筆者與少英兄的業師，即水彩畫家劉其偉先生，對素描曾經有一段幽默之詞：「我把畫家的素描稱作『裸現』；因爲它的畫面不事增減，有如中國畫的白描，又如明星們的素顏 —— 從這裡你可以看到畫家在**藝術**上的眞面目和眞功夫。」

　　其偉先生的妙喻，雖可莞爾，但却蘊藏著中肯的眞理。少英兄蒐集了他的鉛筆素描、炭精筆素描、簽字筆素描，以及一般畫家祕而不宣的，如人像和風景畫步驟圖解集印成冊，公諸于市；像這樣的「裸現」，實爲藝壇所鮮見。

　　總體而言，少英兄的素描作品樸實而靈動，沉穩中見瀟灑，運筆簡潔却富變化黑白中的色階層次分明。每幅畫作都留有適當的空間，使畫已竟而意猶未盡，這正是詩意的表現；宋人黃山谷詠畫家李成的詩句：「李侯有句不肯吐，潑墨寫作無聲詩」，少英兄他肆意揮洒的墨色線條何異潑墨！？

　　德國哲學家黑格爾（G.W.F. Hegel）認爲藝術是理念感性的形象；繪畫、音樂、詩的表現根源都是心靈的表現。從這個角度去探索，即可讀懂少英兄素描的內蘊了。

　　撇開少英兄素描作品表象上的運筆趣味、構圖趣味和表現手法趣味來看，他應是跨進了中國畫家「以情觀物，以新感物」的境界；數十年來，少英兄執著於他那面對土地、面對生靈，面對生活的畫藝；不僅感染了埔里一鄉人對藝術的認知。他的藝術行腳更踏遍了台灣全島，且及于中國大陸，更遠涉歐美、日、韓和東南亞；他的這一藝術情懷，似乎只有南朝人劉勰，在其大著《文心雕龍》中的兩句名言勘可描繪：登山則情滿于山；觀海則意溢于海。

<div style="text-align:right">2015年5月中瀚脫稿于台北思雲軒</div>

Lyrical Expression of Poetic Spirit
Crystallization of Charming Delights

Art critic **Wu Yue**

People generally misunderstand that sketching is merely an introductory lesson of western painting; but actually since the end of 14th century, sketching has long become an independent art, equaling oil painting, watercolor, pastel and printmaking. Similarly, it has a wide range of expressive elements, including volume, space, depth, color gradation and texture. Therefore, a sketch has already advanced to be a representative artwork to demonstrate an artist's creativity. Michlamgelo, one of the three Renaissance grandmasters, had once presented his sketches as noble gifts.

It has been seven centuries since the end of 14th century and the status of sketching has been growing more prominently. As early as in the mid-19th century, Henri Matisse, a great French painter and the leader of Post-Impressionists and Fauves, considered sketching to be the purest way to express emotions as based on lines, and he said, "sketching is like a generator of light, which contains saturated emotions and abundant delights."

Reviewing the world of Chinese art, there are similar remarks; in the 1930s, Zong Baihua, a critic of Chinese art, had a pertinent comment on sketching:

Both sketching of western painting and linear drawing of Chinese painting have cast off the variations and splendors of coloring. In simple forms, they directly master the profiles, movements and spirits of objects. The artist is engaged in a face-to-face fight with the creator through eyes, hands and heart. The objects reveal genuine forms under sketching, and the artists herein demonstrate their skills and varied personalities.

In mid-January of 2015, I received an invitation from Shao-Ying to his painting exhibition of Floral Fragrance in Ink at Harvest Construction in Taipei. Upon entering the venue, my breath was taken away by the exhibited works, which were all beautiful sketches done in the style of five-color ink, shining through the clouds of ink. The scenes depicted by this series of works cover the famous center of culture and education in Taipei around areas of Luosifu Road, Qingtian Street, Tongan Street, Pucheng Street, etc., including important scenic spots like National Taiwan University Main Gate lined with coconut trees, Coconut Tree Boulevard, Fu Bell in memory of the educational predecessor Mr. Fu Sinian, National Normal University campus with lush woods, serene and elegant Qian Tian 76, Kishu An Forest of Literature.... This batch of thoroughly and vividly descriptive sketches delivers a message to the audience like a sense of reunion with good friends, leading to the repeated taste of these scenes such as nostalgia loaded by each aged building, falling twigs of time-catalyzed old trees, dusted and mottled furnishings of architectural facades.... These are only two-dimensional depictions, but they, under free strokes of Shao-Ying, have led us into an in-depth time tunnel, leaving profound feelings and long-lasting aftertaste. It was a genuine artistic feast for me, a long-time Taipei resident.

It has been more than half a century since Shao-Ying and I became bosom friends. In the 1970s, we were very close when Shao-Ying worked at Taiwan Television Company (TTV) as Art Director and I, treading in his footsteps, worked at Chinese Television System (CTS) as Art Director. Later, Shao-Ying was promoted to be Head of Art Department at TTV, while I was also lucky enough to be raised as Head of Art Department at CTS. During the age of three old TVs (TTV, CTS and CTV) monopolizing the broadcasting market of Taiwan, the competition among TV companies was very fierce, but Shao-Ying and I had kept our personal friendship all the way at a pleasant and sweet level with mutual respect and encouragement. I still remember in those years, CTS was producing the drama series of Justice Bao, forcing six production teams to film in progress each day. Unfortunately, we were seriously short of studios due to reconstruction of old buildings. We had to make requests everywhere. Thanks to Shao-Ying for his assistance and introduction, we were finally able to lease the studio of Guangchi Program Service, thus relieving our urgency.

In 1991, Shao-Ying retired and moved to Puli. I retired in 1995 and later traveled to the U.S. to spend my leisure life. We had then kept in contact occasionally by letters despite our long distance. When Shao-Ying migrated to the countryside at Puli in the central region from Taipei in 1991, people generally thought he wanted to follow the example of Wang Wei, a poet of Tang Dynasty, to be an idyllic hermit. However, Shao-Ying was actually determined to escape the urban tumult and squalor in order to concentrate entirely on painting. It is like a western saying that the purpose of submergence is to leap.

When the 921 Earthquake broke out in the central region in 1999, Puli became a serious-hit disaster area. Shao-Ying, disregarding hardship or dangers, finished a hundred more sketches on the theme of catastrophe in the disaster area, which have been donated to the collection of National Taiwan University Library. His selfless deed has revealed another face of his compassion as an artist and also showed his persistent pursuit of artistic expression. I have resumed my friendship with Shao-Ying since I returned to Taiwan in 2011 and frequently read his essays. I genuinely admire his devotion and enthusiasm for art.

I recall the watercolorist Mr. Max Liu, the teacher of both Shao-Ying and I, had once made a humorous statement on sketching, "I call the sketch of painters as a 'naked expression,' because its picture doesn't intend to increase, just like the linear drawing of Chinese painting or the face of a star without makeup, from where you could see the true colors and ingenuity of a painter in the line of duty."

The witty metaphor of Mr. Liu may make us smile but indeed contains pertinent truth. Shao-Ying compiles his pencil sketches, charcoal-pencil sketches and marker pen sketches, as well as the Step-by-Step Figure and Landscape Sketching Illustrations that would normally be kept in secret by painters, into a book for publication. Such a "naked expression" is truly conspicuous in the art world.

Overall, the sketching works of Shao-Ying are simple but dexterous, serene but spontaneous, and done by concise strokes but full of variations in distinct gradation from black to white. Each drawing has been left with proper space to make the final work look like unfinished, which is precisely a poetic expression. Huang Shangu of Song Dynasty wrote the verses as an ode to Li Cheng, "the nobleman Li refused to reveal his sentences, splashing ink to write a soundless poem." The unbridled, spontaneous splattered ink lines of Shao-Ying are indeed no difference from splashes of ink!

German philosopher Hegel considered that art is the formation of perceptive ideas; painting, music and poetry are all rooted in mental expression. From this perspective, it is easy to explore and understand the intrinsic meanings of Shao-Ying's sketches.

Judging from the formal delights of Shao-Ying's sketches in stroke, composition and artistic approach, he should have stepped into the realm of "observation by feelings, perception by novelty" for Chinese painters. For several decades, Shao-Ying has devoted himself to the art of painting on his association with land, living beings and life. He has not only affected the knowledge about art of the people at Puli, but also traveled around the entire island of Taiwan, even the Mainland China, and further Europe, America, Japan, Korea and Southeast Asia. His artistic soul can best be described with two lines in a masterpiece, *The Literary Mind and the Carving of Dragons*, written by Liu Xie from the fifth century:

Climbing the mountain, then the heart is full of the mountain
Watching the ocean, then the love is overflowing into the ocean

Written at Siyunxuan, Taipei
mid-May, 2015

縱放自如的眼中世界

藝術評論家　亮軒

　　孫少英是一位少見的，一生專注在畫畫的志業上的畫家，在他這一生80年以上的歲月中，到底畫畫了多少張畫？想來他自己也不太算得清吧？只要看看他的素描，就知道他是一位非常勤奮，無時無地不在畫畫的畫家。畫家有千百種，有工細的，有寫意的，有抽象的，有具象的，有突顯個人風格的，有反應天地萬物的。孫少英的畫，特別讓我感受到他是以畫筆在寫他的日記。寫日記是最不做作的表現，他有什麼就畫什麼，畫家要表現的就是自己眼下所見，不挑不揀，隨遇而畫，總能自自然然的透出他那平隱、自在、無所為而為的胸懷。像這樣的畫家，在今天的畫壇，彌足珍貴。

　　孫少英的素描趣味，用心一點品賞，很容易發現那就是他生活的趣味。有清靜的山居、有熱鬧的市衢、有小橋流水、有高樓大廈、也有古老的巷弄，還有他眼中遠近的人物。凡是足跡所至，他都能在短短的時間裡勾描而出。而無論怎麼看他的畫作，最難得的是他的不做作，讀其畫如見其人，溫和誠懇，自然親切。畫而能如其人，並且是一位平淡天真的藝術家，愛孫少英之畫，最著力的卻也就在這一點。

　　他對自己的作品說得很少，是啊，要是小說家時時的要在作品中自道幾句，便徒然顯得力不從心而已。有的時候我想，畫作上真不必長篇累牘的寫文章，正是因為他們的畫筆已經道出了他那難以道斷的心意。

　　藝術家原本就是以他們最為熟悉的方式「說話」。音樂家用曲譜樂器，雕塑家用泥土、石塊、合金的造型，詩人鑄字煉句等等，都是在用他們特殊的方式「說話」，以補我們平素語言之不足。的了呢嗎知乎者也的平常語言到底無法滿足我們所有的傳達與接受的需要，人生需要藝術，意盡於此。孫少英先生畫了一生，日以繼夜。顛沛造次必於是，安隱和樂必於是，自少而老從不懈怠，依我看，他個人只是為畫而畫，不伎不求，而在自然中，表現了這位其實也經歷了漂流迷惘的歲月的畫家的堅持，堅持在他能力所及中優雅而有尊嚴的活下去。在他的筆觸間，我們辨識得出來這樣可貴的精神。

　　畫家入門，應該就是素描，然後是水彩、粉彩、油畫，也可以嘗試一些別的，像是拼貼、版畫等等。領域無邊無際，直似千山萬水。可有意思的是，畫家畫了一生，到了筆隨心心隨筆的境

界時，卻又會很容易的回到了素描。繪畫的基本功由素描開始，繪畫的最高境界卻也常常隱藏在素描的畫作中。「眾裡尋他千百度，驀然回首，那人卻在燈火闌珊處」，因為在那樣的情境中，直如孫少英所說的「方便」。只是這樣的方便，也不是人人辦得到的，水墨畫中有的作品讓人評作「墨豬」，素描何其不然？一支6B鉛筆，沒一會兒便耗去了半枝，而滿紙黝黑，毫無層次，也是硬筆的墨豬。孫少英說鉛筆素描第一個好處是方便，這一點應該沒有置啄的餘地。然而他又說，第二是灰階多，這就要多想想了。一眼看去的是顏色繽紛的世界，成為黑白，就要具備看出他所謂的灰階的本事，色彩容易平面處理，黑白就要看得出縱深，畫家沒有幾十年來不斷畫畫鍛鍊出的好眼力，哪裡辦得到？所以了，到了後面有些是簽字筆的作品，那可是無所謂灰階可用的，他用的是疏密，照樣的表現出眼下所見無限層次的世界。這個他兩個字說出來的專業言語，卻是畫家心手一生一世的努力。

孫少英不是一眼便能讓人驚艷的畫家，他應該從來也沒有想要大家在第一眼中便驚覺於他的閃亮奪目。然而他的畫很能讓人細細玩味，越看越走不開。比如說在這一本畫冊中有幾幅簽字筆跟水彩著色的作品，真的便如他說的「灰階」，其實他的「色階」還真是不同凡響，不論是屋中的光影，還是野外的山石樹木，在任情卻恰到好處的筆觸中，醺然天成的濃淡中傳達了在時間流動中最迷人的剎那。能以畫筆如此的擒縱渲染，反而襯托得在畫冊中他的那三言兩語更堪玩味。

Free Expressions of the World as Seen

Art critic **Liang Xuan**

Sun Shao-Ying is a rare painter who has devoted his entire life to artistic aspiration. In the end, how many works have been painted during the 80 plus years of his life? Perhaps the number is unclear even to him. Just take a look at his sketches, and we know that he is a very diligent painter who is constantly working whenever, wherever. There are thousand kinds of painters varying from spontaneous, abstract, realistic, individualist, to natural or universal. The paintings of Sun Shao-Ying have particularly impressed on me that he is keeping his personal diary by paintbrushes. Keeping a diary is the most faithful expression. He paints whatever he sees. A painter is about expressing the things as seen unselectively. To paint as things come by chance is a way to naturally show the serene, easy and unintentional state of mind. A painter as such is rare and precious in the art world today.

The sketching delights of Sun Shao-Ying, under careful scrutiny, obviously reveal his delights in life. There are tranquil mountain resorts, lively urban scenes, bridges and streams, towering buildings, antique alleys and human figures far and near as seen through his eyes. He has been able to sketch within very short time the scene wherever he has left his tracks. And his unpretentiousness, as demonstrated in all his paintings, is especially hard to come by. Studying his paintings is like meeting him in person, who is gentle, sincere, natural and friendly. His paintings exemplify his personality as a simple and unaffected artist. This is the most important reason for me to love the paintings of Sun Shao-Ying.

He seldom talks about his works. Indeed, if a novelist constantly makes some remarks in the work, the readers would only feel a sense of incompetence. Sometimes, I think it is really unnecessary for painters to make a long story in a painting, because their paintbrushes have already delivered the unspeakable intents.

Artists tend to "speak" in their most familiar way. Musicians use music scores and instruments. Sculptors use malleable forms of clay, stone and alloy. Poets use refined words and sentences. They all "speak" in their special way in order to compensate the inadequacy of our normal languages. The ordinary oral expressions after all are unable to satisfy our every demand to communicate and receive. Life needs art because it means a lot. Sun Shao-Ying has spent his entire life in painting diligently from day to night, in wanderings and haste or in peace and happiness, from youth to old age. In my opinions, he paints for the sake of painting only without any expectation of gains, and naturally, he has demonstrated his perseverance as a painter during his sometimes wandering and uncertain life, because he has persisted in living with grace and dignity within his capacity. Between his brushworks, we are able to discern such a noble spirit.

The fundamental lesson for a painter should be sketching, followed by watercolor, pastel, oil painting, and some other trials, such as collage or printmaking. The range of fields is unlimited like numerous mountains and waters. It is funny that after a whole life of painting, a painter has reached the culmination of working freely at ease but then is most likely to return to do sketching. The basic skill of painting starts with sketching, and the acme of painting is often hidden in a sketch. "Over the crowd I went searching for him thousands of times, while the very moment I turn back, and there, by the dim light, is him." And such is exactly the scenario like the "convenience" in the words of Sun Shao-Ying. Yet, such convenience is not something everyone is able to accomplish. There are certain works in ink painting criticized as "inky pig". Sketching could produce the same results. A pencil of 6B might be used up to the half after a while, but the entire paper only shows

black without any gradation, like an inky pig by hard pen. Sun Shao-Ying said the first advantage of pencil sketching is convenience, which should be unarguable. Then he said the second advantage is more gradations of grey, which might need more thoughts. To turn a visually colorful world into black and white requires the capability of grey gradations he has mentioned. Colors are easy to be handled in a plane, but black and white requires vertical depth. Without the good eyes trained by decades of continuous painting, it is almost impossible to accomplish. Finally, there are some works by marker pen, which could not be handled by grey gradations. What he has applied is spacing to similarly demonstrate the world of unlimited layers as seen by him. These two professional jargons he said would have taken a whole life of efforts with the heart and hands of the painter.

Sun Shao-Ying is not a painter who surprises the viewers instantly. He likely has never intended to startle people at first glance by his dazzling brilliance. However, his paintings are worth appreciating in details, without interruptions. For instance, there are several works by marker pen and watercolor in this catalogue demonstrating "grey gradations" as he mentioned. Honestly, his "grey gradations" is remarkably unique, including light and shadow in the interior or mountains, or rocks and trees in the wilderness. Under his spontaneous but precise brushwork, integral blending of dark and light colors has expressed the most charming moment in the flow of time. He is able to master pens with such dexterous rendering, and in contrast, his several comments in the book are even more accentuated and worth pondering.

丟掉你的橡皮擦

盧安藝術執行長　**康翠敏**

　　談起與孫少英老師的緣份，就得由九二一大地震那批素描畫作談起。那時候孫老師以鉛筆素描災區震後的實況；其中有倒塌的民房、大樓及學校，破碎的廟宇，受難的災民，救災團隊…等等。這片受傷後的台灣土地在只有黑白灰調子的素描中，何以有如此震撼性的張力與美感，讓我感慨不已也感動萬分。

　　2013年起，盧安藝術在孫老師授權之下，開始為他代理畫作、畫冊的經紀工作，並且由原本一年一展一書的習慣作法，擴大為一年3～4檔展覽，展覽期間又會搭配多場示範講座，畫冊的出版則維持是一年一書的企劃。2013年出版的《水之湄－日月潭水彩畫記》是集結歷年的日月潭水彩畫，為數共210幅，也是台灣相當有份量的水彩畫集。2014年出版的《荷風蘭韻》，改走「西畫中韻」的風格，以水彩來呈現「荷」與「蘭」的風貌，並附以唐詩、宋詞或孫老師白話詩詞來襯托水彩畫特有的渲染、留白、重疊的韻味，開創了水彩畫冊的另類風格。

　　其實，孫老師歷年的水彩畫冊中都藏夾有素描作品，《九二一傷痕素描集》、《埔里情》兩本畫冊更全部是素描作品。甚至1976年孫老師在美國新聞處林肯中心舉辦的第一次個展，也是以素描為主軸。素描在孫老師眼中可說是西畫的根基，也是純熟畫作功力的展現。對於熱愛、著重寫生的孫老師而言，沒有素描的精準練習在先，就談不上水彩的自由揮灑。

　　於是，2015年的孫少英年度畫集，就以《素描趣味》來定調了！

　　坊間的素描教學本何其多，不管中文版、外文版都各有特色風格。那麼，盧安藝術所出版的《素描趣味》，到底「趣味」何在呢？

　　趣味（一）：孫老師將他所創的「一點延伸法」應用在素描上，強調一開始練習就不要老是用橡皮擦來修正，久而久之自然就習慣，畫面也就會清爽。這次畫冊中的人像、風景素描示範分鏡圖，都重新拍攝了原畫，清楚又明瞭。

　　趣味（二）：孫老師的素描並不只有「非黑即白」，而是以4種不同筆材來呈現黑、白、灰的畫面。每幅畫作都會因為濃淡度、粗細度、疏密感，展現出各有差異的美感力度。其中有幾幅更搭配淡彩或單色，營造出不同的趣味感，顯得精彩又活潑。

趣味（三）：孫老師早年任職台灣電視公司新聞部美術指導時手繪的新聞插卡，如今已是絕響，這次則一起在附錄中露臉。那個年代電視尚未數位化，也沒有電腦製圖，針對每一則新聞，美編人員都必須快速繪製生動的插卡，好配合新聞播出。沒有深厚的素描基礎，就無法用簡單線條，如漫畫般地呈現新聞內容。

　　總的來說，《素描趣味》這本書中的種種趣味，讓讀者了解素描不再只是基本練習，而是多元、簡約、明快的藝術展現。

　　孫老師總是強調畫畫要快樂，構圖要乾淨。畫素描時因為沒有色彩，只有黑白灰的色階，一定要用俐落的線條去鋪陳點、線、面，所以就要「丟掉你的橡皮擦」，由「一點」去延伸整張構圖，才能畫得簡潔、畫出趣味來。

Throw Away Your Eraser

CEO,Luan Art **Kang Tsui-Min**

Speaking of my affinity with Master Sun Shao-Ying, I have to mention a batch of sketches on the 921 Earthquake. At that time, Master Sun sketched out the scenes of the aftermath in the disaster areas by pencil, including collapsed houses, buildings and schools, crumbled temples, suffering disaster victims, relief teams, etc. I was deeply grieved and tremendously moved by the sensational tension and beauty in the wounded land of Taiwan as illustrated by these sketches in tones of black, white and gray only.

Starting 2013, the Luan Art has represented Master Sun under his authorization, dealing with his art works and publication. And we have extended our cooperative arrangement from one exhibit and one book per year in the past to annually 3-4 exhibits, each with several demonstrative lectures, and still one published book. In 2013, we published *Searching for Beauty: Sun Moon Lake Watercolor Journal,* compiling totally 210 watercolors about Sun Moon Lake from previous years, which has become a fairly significant watercolor catalogue of Taiwan. And in 2014, we published *Lotus Breeze Orchid Melody*, which features innovatively a style of "western painting in Chinese temperament," representing the bearing of lotus and orchid by watercolor, accompanied by Tang poems, Sung lyrics or Master Sun's modern poetry to accentuate the particular effects of rendering, white space and layering in watercolors, thus initiating an alternative style for watercolor catalogues.

The watercolor catalogues by Master Sun through the years are all accompanied by sketching works. Both *The Scars of 921* and *Sketches of Puli* are entirely compiled by sketching works. Even Master Sun's first solo exhibition held at Lincoln Center of United States Information Service in 1976 was focused on the theme of sketching. Master Sun considers sketching as the foundation of western painting and also a way to demonstrate mastery in drawing maturely. For Master Sun who loves and emphasizes nature drawing, it is not possible to freely exploit watercolor effects without perfect sketching practice in advance.

Therefore, we have set the tone for the 2015 annual painting catalogue of Sun Shao-Ying as *Sketching Delights*.

There are so many sketching tutorials in the bookstores, and each version, Chinese or foreign, has come with its own special features. So, what on earth is "delighting" in the publication of Luan Art, *Sketching Delights*?

The First Delight:

Master Sun applies his invented method of One Stroke Extension to sketching, insisting on a practice without modifying by erasers from the beginning to naturally form a habit in due time and also to make clean pictures. In this catalogue, all the step-by-step demonstrations of figure and landscape sketches have been newly photographed from the originals to ensure clear-cut images.

The Second Delight:

The sketches of Master Sun are not limited to black or white, but rather featuring black, gray and white pictures with four different pens. Each work displays individual difference in aesthetics and dynamics through various degrees of shading, thickness and spacing. Among them, there are several sketches revealing distinctive tastes expressively and vividly as matched with light colors or monochrome.

The Third Delight:

The hand-painted news cartoons of Master Sun during his position as Art Director of the Art Department of News Division, Taiwan Television Company have now become inimitable, which are presented together in the appendix this time. At that time, there was no digitization or computerized images, so art editors had to quickly draw lively illustrations to be broadcast in the news program. Without a solid foundation of sketching, it would have been impossible to use simple lines to animatedly represent the news contents.

In general, the various delights revealed in *Sketching Delights* will lead the readers to understand that sketching is not merely a basic practice but rather an artistic representation, which is diversified, succinct and vivid.

Master Sun repeatedly emphasizes that painting is a happy activity and the composition needs to be clean. There is no color in sketching, only gradations of black, white and gray, so it demands clean lines to arrange the points, lines and planes. Therefore, one must "throw away your eraser" and extend from "one stroke" to compose the entire picture in order to create a succinct work, delightfully.

我追求的素描趣味

孫少英

這篇小文內容包括以下四點：

（一）我畫素描用的紙和筆。

（二）我追求的素描趣味。

（三）寫生對我的重要性。

（四）我對繪畫藝術的一些想法。

（一）我素描用的筆和紙：

1. 鉛筆：我用過很多牌子的鉛筆，現在專用OTTO 6B日本製造，木桿很好削，筆心黑度合適，無雜質（沙粒），畫起來很順手。我每次削好12支，剛好畫完一張畫，中間不需要削鉛筆，不會打斷繪畫情緒。美術用品店賣的素描紙，有國內製，有外國製，正面較粗，背面較細，一般人都是用正面，我則喜歡用較光滑的一面，原因是用力畫線條時，鉛粉附著較堅實，顯得剛勁有力。早期我出版的《九二一傷痕素描集》，大半是用西卡紙，當時就是想求得線條堅實的效果。現在這些素描原畫都存在台大圖書館裡。

　　用鉛筆畫素描最大的好處，第一是方便，第二是鉛筆的灰階多。水墨畫家都知道墨分五色。鉛筆的灰色階層，依手的輕重可出現各種灰度，在調子的要求上，極為理想。缺點是黑度不夠，有時覺得力道不足，因此我常常換用炭精筆。

2. 炭精筆：這種筆跟鉛筆最大的不同是有相當的黑度，用力畫幾乎跟墨汁一樣，輕輕畫仍有理想的灰色階層。因為炭精粉的粒子較粗，大張紙較適合，我通常都是畫對開，用粗面，光滑面附著性不夠。

3. 簽字筆：我習慣用的筆是Unipin 0.5，效果相當於早期的鋼筆或針筆。簽字筆固定是黑色，沒有鉛筆或炭精筆可依靠手的輕重畫出黑白灰的調子，但若能機巧的以線條的疏密，仍可掌握一部份的深灰和淺灰。如賦以淡彩，更會增加畫面的立體感和層次感。假若要上淡彩，一定要用油性筆。簽字筆用紙，不宜太粗，否則畫起來不流暢，筆心也易磨損。

4. 墨筆賦彩：我用的墨筆不是書法用的正統毛筆，而是用禿了的最小號油畫筆，墨汁和清水混合使用，以分出線條的深淺。有人用削尖的木條或竹製筆，效果跟我用的油畫禿筆差不多，都屬硬筆類，比起毛筆好控制，似乎也不需要毛筆那麼好的功力。

單純一張墨筆畫，會覺得單調，我通常會酌量賦彩。所謂賦彩，我是引用南齊謝赫六法中的「隨類賦彩」一詞。因為畫素描為了保持線條的美感，通常都是上淡彩，墨筆畫線條墨度夠，上彩濃一點，對線條沒有影響，所以我用賦彩一詞，意思是可以重疊上色，或盡量強調彩度和明度，跟一般水彩畫的效果接近。有時因為墨筆線條的突出，使畫面更顯得強勁有力。

墨筆畫用紙，我習慣用Arches 300p，一方面是紙面粗度合適，另一方面這種紙是水彩畫的專用紙，絕不吃色，也不褪色。

（二）我追求的素描趣味：

畫素描無論用什麼筆，都是以線條為主，線條的趣味極為重要，因此，線條應是一張素描的靈魂。

什麼是好線條？我常跟同學說，心裡不拘束，畫出來的線條就是好線條。畫畫跟運動選手一樣，越放輕鬆越有好成績。畫畫最大的勁敵就是拘謹，沒有下筆，心裡就擔心畫不好，在這種情況下，絕對畫不出好畫。

我常常勉勵自己有兩句話：**要有精準的能力、要有揮灑的本領**。

有些情況下，可以變形或誇張，但基本的精準能力絕對重要，否則在結構上會鬆軟散亂。有了基本的精準能力，即有了充份的自信，自然就能揮灑自如，無拘無束，即所謂「爐火純青」，「渾然天成」。

我想以書法為例，我最欣賞的一篇書法是唐朝顏真卿的〈祭姪文稿〉，其特色是：

1. 在為姪子哀傷的情緒下，絕對不會顧及到字體的結構和排列，自然純真的流露，才真正是藝術的最高境界。

2. 顏真卿是唐宋八大家之一，〈祭姪文稿〉是中國三大行書之一，因為是手稿，字體十分潦草，有許多塗改之處，但其深厚的功力和灑脫的筆勢，表露無遺。我從大陸買回一本〈祭姪文稿〉的放大版，常常翻閱，愛不釋手，藝術品的誘惑力，我從這篇〈祭姪文稿

〉中，有了深深的體會。中國書法的線條美感，和西畫素描的線條趣味，實具有異曲同工之妙。

線條趣味之外，調子也很重要，所謂調子，就是黑白灰三種色階的搭配。有人畫素描，常常採速寫方式，紀錄成份大。我每次素描寫生，雖也是速寫，但我會從構圖到黑白灰調子的安排，認真的完成一幅素描作品，回到畫室，常根據素描再完成一張水彩，極有參考價值。

快速的素描稱為速寫。我除了畫風景以外，還喜歡人物速寫，在公共場所或是在街上，靜靜的觀察各種類型的人物，形形色色，真是很有趣味，也具有相當美感。就以女性的衣飾來說，長的、短的、寬的、窄的、晶晶亮亮的、邋邋遢樸實的，無論從正面、側面、背面看，其形態和動態的變化，確是速寫的好題材。

朋友中，看到臉型輪廓明顯的，或是有個性有特徵的，我往往會主動徵求對方同意，隨手畫一張速寫。親友聚會的場合，常常有人要求我為她（他）畫一張素描，興致來了，會連畫數人。這種「應酬」，常會在聚會間增添不少和樂情趣。

我畫人像速寫，已不計其數，畫的多，養成了我一套獨有的畫法－「一點延伸法」，精準也快速。（請參閱84頁〈人像速寫步驟圖解〉）

（三）寫生對我的重要性：

我很喜歡寫生，寫生已成了我的樂趣、習慣和功課。

先說樂趣。

許多人都是旅遊順便寫生，我則是寫生順便旅遊。寫生的樂趣在哪裡呢？

1. 美景在前，單純欣賞，是一種淺嚐即止的層次。
2. 用照相機拍下來，回到家裡再慢慢欣賞，是一種事後品味的層次。
3. 畫下來，欣賞品味之餘，會有收穫感，所以又是一種收穫的層次。
4. 寫生時，把個人當時的感受，透過線條、色彩、調子、構圖等種種變化，組合成一張自己理想的作品，當是一種成功、滿足的更高層次。

再說習慣。

俗語說習慣成自然。我常想，書法家寫字，每一筆與每一筆之間應毫無考慮空間，尤其是寫行草，如稍有猶豫、停滯，整篇「行氣」將大受影響。畫素描也是同樣道理，要養成開

筆後疾速不停、一氣呵成的習慣。凡事不覺得困難，漸漸就習慣成自然了。

再說功課。

這些年我畫畫都是系列性的，如日月潭、阿里山、台灣小鎮、台灣離島等，已完成十餘個系列，每年固定出版一本書，舉辦水彩及素描個展，也投稿報刊發表。朋友開玩笑說我一鴨三吃，我說這都是我喜歡寫生的好處。

現在我的畫由盧安藝術公司代理，他們幫我策劃展覽及出版畫冊，我則專心畫畫，外出寫生或是在畫室作畫，每天成了我的功課。好在這種功課對我沒有一點壓力，原因是我的一切畫作都是直接或間接來自寫生，面對大自然，資源豐富，取之不盡，用之不竭。常年畫下來，駕輕就熟，得心應手，這種功課不但沒有壓力，反而是一種愉快。

（四）我對繪畫的一些想法：

1. 有人高唱創意，難免失之品質，我的想法是：創意是一時的發想，品質是長年的養成，兩全最好，如不得兩全，我寧失之創意，絕不捨品質。

2. 繪畫不打草稿是好習慣，也是愉快的來源。譬如畫複雜的街景或市場，細微末節的草稿打完了，繪畫的樂趣也磨掉了。同時，照稿填色，毫無揮灑空間，繪畫的樂趣也喪失了。如何不打草稿，請參閱拙著《從鉛筆到水彩》一書。

3. 藉實驗的方式，尋求一種偶發或意外效果，而捨棄傳統筆趣功力的繪畫，會有良好的視覺效果或所謂「形式美」，但是仔細觀賞，我會覺得畫面空泛、貧乏。

我一輩子所追求的素描趣味就是前面提過的兩句話：精準的能力和揮灑的本領。在繪畫的道路上，有了精準的能力，自會有充足的自信，想畫什麼就畫什麼，沒有困難，沒有障礙，這樣才能真正體會出繪畫的樂趣。揮灑的本領是奠基在精準的能力上，我用本領一詞，為的是強調從事繪畫能夠揮灑自如，實非易事，除有功力以外，更要有天分。我一直認為揮灑的本領是通往藝術境界的最佳途徑。

My Pursuit of Sketching Delights

Sun Shao-Ying

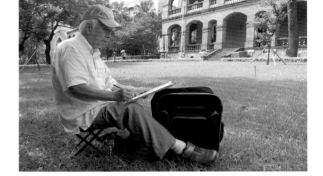

This essay contains the four following parts:

(1) The types of paper and pens I use in sketching.

(2) My pursuit of sketching delights.

(3) The significance of nature drawing for me.

(4) My thoughts on the art of painting.

(1) The types of paper and pens I use in sketching.

Pencil:

I have used many brands of pencils. Now I only use OTTO 6B, manufactured in Japan. Its wood rod is easy to sharpen and its core is in proper degree of blackness without any impurity like sands. It feels smooth to draw with this pencil. I sharpen 12 pencils each time, just enough to finish a work without interruption of my painting mood by the need to sharpen pencils in the process.

The sketch paper sold in art supply stores covers both domestic and foreign brands. The paper is rougher in the front and finer in the back. People generally like to use the front side, but I like to use the smoother side to which the lead powder can be more firmly adhered under mighty lines in order to show vigor and intensity. Most of my works in *The Scars of 921* were sketched on smoother Bristol papers for better result of mighty lines. Presently all the original works of my earthquake sketches are in the collection of National Taiwan University Library.

The biggest advantage to sketch with pencils is firstly convenience and secondly more gradations of gray. All the ink painters know ink has five colors. Different manual forces may demonstrate the gray gradations of pencils to generate various degrees of grayness. It is very satisfactory to fulfill the demand of toning. But inadequate blackness is the shortcoming. Whenever I feel I am short of strength, I would change to use charcoal pencils instead.

Charcoal pencil:

It is most different from pencils in its considerable degree of blackness. It is nearly effective as ink when applied forcefully, yet it can still produce proper gradations of gray in lighter strokes. The particles of charcoal are coarser, so it is better to use larger paper. I usually use folios and choose the rough side, because the smooth side lacks adhering capacity.

Marker Pen:

I constantly use the fineliner pen, Uni Pin 0.5, which is as effective as the early ballpoint pen or needle pen. The fixed color of the marker pen is black. Unlike pencils or charcoal pencils, it cannot generate tones of black, white and gray

by manual strength. However, dexterous spacing of lines will master a certain degree of deep and shallow grayness. When matched with light colors, the picture can further display three-dimensionality and distinct gradation. For light color application, it requires oil pens. The paper for marker pens cannot be too rough, otherwise, the drawing will not be smooth and the cartridge is susceptible to abrasion.

Application of Color by Ink Pen:

For ink coloring, I choose the blunt, smallest-size oil brush over the traditional Chinese calligraphy brush. I mix the ink with clear water to produce deep or shallow lines. Some people use the sharpened wood sticks or bamboo pens, which are as effective as the blunt oil brush I use, because they are all hard pens, easier to be controlled than writing brushes, also demanding less mastery than writing brushes.

A simple ink painting looks monotonous, so I like to apply some colors appropriately. For coloring, I refer to the phrase, "application of color by suitable type" in the "Six Principles of Chinese Painting" by Xie He in the Southern Qi Dynasty. Light colors are favored in sketching to maintain beautiful lines, while the lines are considerably black in ink paintings to hold darker colors without being affected. Thus I use the term, application of color, to mean coloring in layers and emphasis on brightness and tonality, approaching the effects of watercolors. Sometimes, the accentuated lines by ink pens create a stronger and more vigorous picture.

For painting with ink pens, I choose the paper, Arches 300p, because it has proper degree of roughness and it is also specially used for watercolor painting, preventing the coloring from dilution or fading.

(2) My pursuit of sketching delights.

Sketching is based on lines no matter what kind of pen is used. The play of lines is extremely important. Thus, lines should be the soul of a sketch.

What makes good lines? I often say to my students that good lines can only be drawn from a liberal heart. Painting is like doing sports where better records can be achieved by more relaxation. The biggest enemy of painting is restraint. Worrying about the result of a work even before the first stroke would never lead to a good painting.

I always encourage myself with two sentences:*I should cultivate the ability of precision. I should cultivate the competence of working with ease.*

Under certain circumstances, distortion or exaggeration is allowed. However, the basic ability of precision is absolutely significant, otherwise the composition becomes loose and messy. The basic ability of precision entails full confidence, naturally resulting in free and easy expression. And perfection or high excellence can be naturally and integrally achieved.

For example in calligraphy, my favorite work is "Draft of the Eulogy for My Nephew" by Yan Zhenqing of the Tang Dynasty. It has the following characteristics.

- Affected by grieve for his nephew, he would certainly be inattentive to the structure and arrangement of characters. Natural and pure expression of emotions is genuinely the highest state of art.
- Yan Zhenqing was one of the Eight Masters in the Tang and Song dynasties. The "Draft of the Eulogy for My Nephew" is one of the three Chinese masterpieces in running script. Because it was a manual draft, the calligraphy is very illegible with many traces of tampering, but fully revealing solid mastery and free brushwork.

I have bought an enlarged version of "Draft of the Eulogy for My Nephew" from Mainland China. I often enjoy scanning it and cannot part with it. The alluring power of an artwork as shown by this "Draft of the Eulogy for My Nephew" has deeply impressed me. The linear beauty of Chinese calligraphy and the linear delight of western sketching are different in approach but similarly marvelous.

In addition to the linear delight, the tonality is also significant, which is made of matching gradations of three colors: black, white and gray. People generally make quick sketches in order to keep a record. Every time I draw from nature, I would not only make a quick sketch but also finish a drawing work earnestly from composition to arrangement of tonality in black, white and gray. When I return to the studio, I would then complete a watercolor based on the sketch, which is a great reference. Rapid drawing is called sketching. In addition to landscape painting, I also like to do figure sketches. It is truly delightful and very beautiful to observe quietly all types of characters in a variety of forms in the public area or on the street. I have finished numerous figure sketches. Through a considerable amount of works, I have developed my own unique method, One Stroke Extension, which is precise and fast. (Please refer to Step-by-Step Figure Sketching Illustrations, page 84.)

(3) The significance of nature drawing for me.

I love to draw from nature. Nature drawing has already become my delight, habit and assignment.

Let me speak of delight first.

Many people travel and draw from nature on their way, but I draw from nature and travel on my way.

What makes nature drawing delightful?

- It is a level of satiation by the first sip to simply enjoy the beautiful scenery in the front.
- It is a level of aftertaste to slowly appreciate it at home as an image captured by a camera.
- It becomes a level of harvest to appreciate the taste after drawing it like a reaped reward.
- It reaches a higher level of success and satisfaction to accomplish an ideal work from combining instant personal feelings through variations of lines, colors, tones and composition when drawing from nature.

Secondly, let me talk about habit.

It is commonly said that habit is second nature. I think when calligraphers write, they should not consider spacing between any two strokes. Especially in running script, any hesitation or standstill would greatly affect the running

brushwork of the entire piece. It is the same with sketching. It demands to form a habit of uninterrupted, smooth flow in drawing from start to finish. Without feeling any difficulty, one would gradually turn the habit into a second nature.

And then, let me elaborate on assignment.

For recent years, I have painted works in series, such as Sun Moon Lake, Alishan, Taiwan townships, offshore islands of Taiwan, etc. I have completed a dozen plus series. I regularly publish a book, hold a solo exhibition of watercolor and sketches, and present essays in newspaper every year. My friends like to joke with me, saying I have gained three rewards from one endeavor, and I would say they are all benefits from my favorite nature drawing.

Presently, I am represented by the Luan Art Co., Ltd. to deal with my paintings. They help me to organize exhibitions and publish catalogues, so I can concentrate on painting, drawing outdoors or working in the studio, which becomes my daily task. Fortunately I feel no pressure from such an assignment, for all my works come directly or indirectly from nature drawing. The nature is an abundant, inexhaustible resource. For many years of drawing, I have become mature and experienced to master it with ease and great skill. This kind of assignment is a delight, instead of pressure.

(4) My thoughts on the art of painting.

1. When people emphasize creativity, quality might be sacrificed. My opinion is that creativity is an instant idea, while quality comes from long-term cultivation. It is best to have both. If not, I would rather choose quality over creativity.

2. It is a good habit to paint without sketching, which is also a source of delight. For example, when painting complex street scenes or markets, after meticulous details of a draft are finished, all the fun in drawing would be consumed. In the meantime, filling the colors based on the design forbids free expression at all, and so the delight of painting disappears as well. For the method of painting without sketching, please consult my book, *From Pencil to Watercolor*.

3. A painting, which seeks an improvised or accidental effect through experimental methods, abandoning traditional brushwork mastery, would come with good visual effects or so-called "formal beauty." But under scrupulous observation, I find the picture to be blank and lackluster.

My pursuit of sketching delights in my whole life sums up the previously mentioned two lines: ability of precision and competence of working with ease. On the path of painting, with the ability of precision, full confidence is ensured to paint at will without any difficulty or obstacle. Thus, it is possible to experience the true delight of painting. The competence of working with ease is based on the ability of precision. I choose the word, competence, to emphasize the rarity to be working with ease in painting, which requires both skill and talent. I firmly believe the best way to reach the artistic realm is through the competence of working with ease.

目錄 Contents

鉛筆素描

鉛筆素描的好處第一
是方便，第二是灰階多，
依手的輕重可出現各
種灰度，在調子的
處理上，極為理想。

請參閱第14頁〈我追求的素描趣味〉一文

Pencil Sketch

The biggest advantage to sketch with pencils is firstly convenience and secondly more gradations of gray. Different manual forces may demonstrate the gray gradations of pencils to generate various degrees of grayness. It is very satisfactory to fulfill the demand of toning.

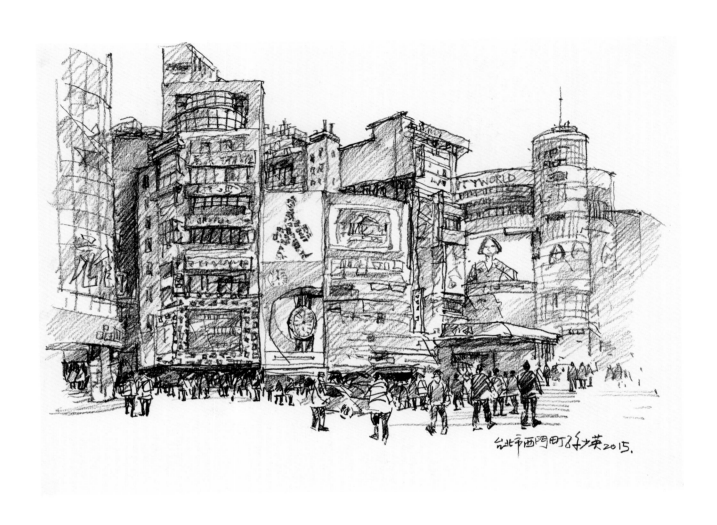

台北西門町（一）　4開　鉛筆　2015
Ximending, Taipei (I) 4K Pencil 2015

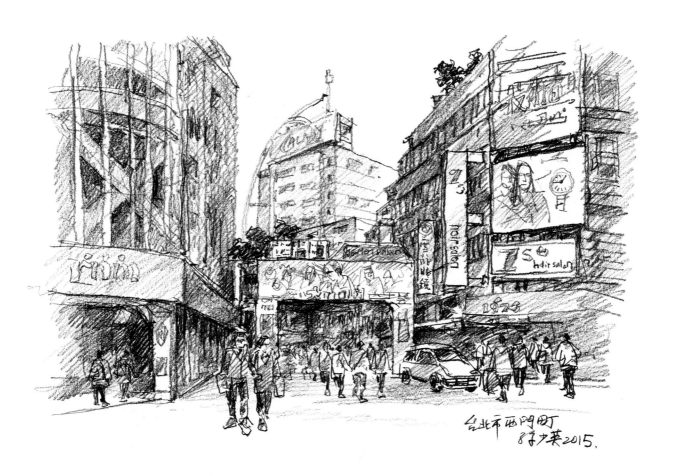

台北西門町（二） 4開 鉛筆 2015
Ximending, Taipei (II) 4K Pencil 2015

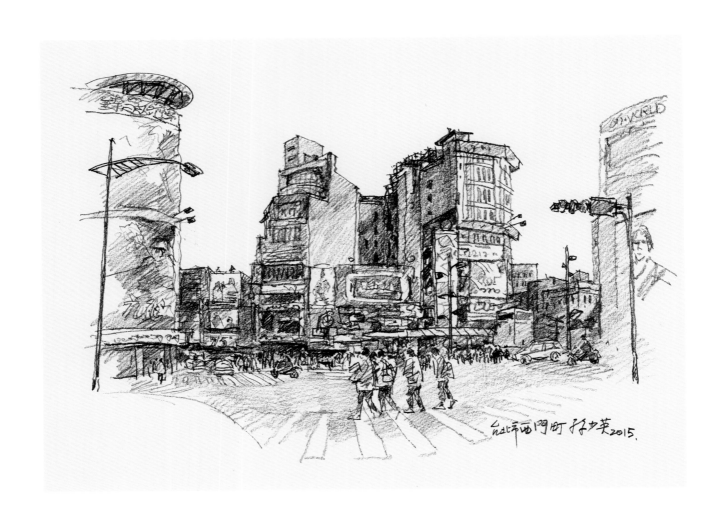

台北西門町（三） 4開 鉛筆 2015
Ximending, Taipei (III) 4K Pencil 2015

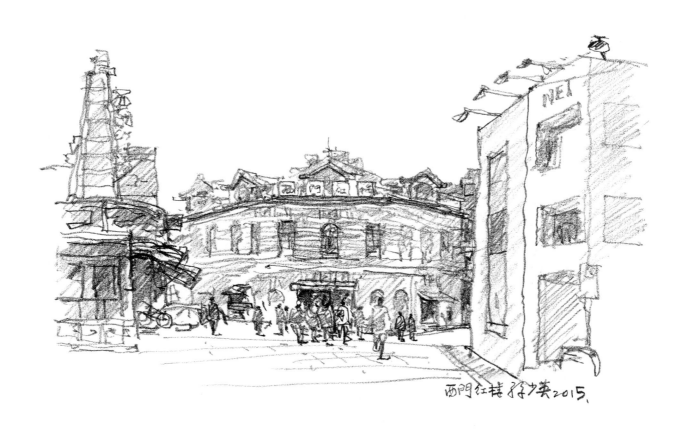

台北西門紅樓 8開 鉛筆 2015
Ximen Red House, Taipei 8K Pencil 2015

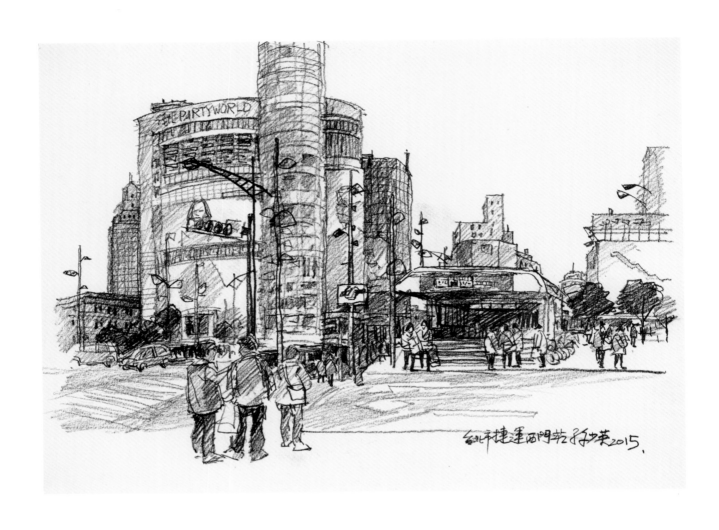

台北捷運西門站　4開　鉛筆　2015
Taipei Metro Ximen Station　4K　Pencil　2015

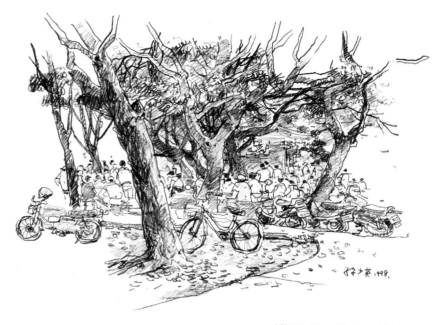

埔里仁愛公園 4開 鉛筆 1998

Jenai Park, Puli 4K Pencil 1998

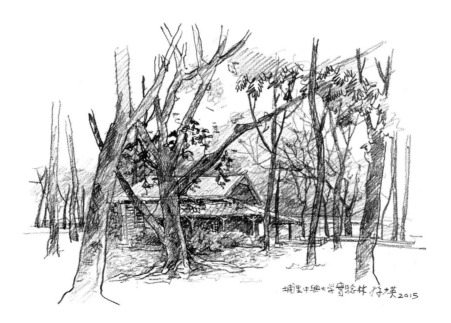

中興大學實驗林 4開 鉛筆 2015

Experimental Forest, National Chung Hsing University 4K Pencil 2015

南投中寮 8開 鉛筆 2002

Zhongliao, Nantou 8K Pencil 2002

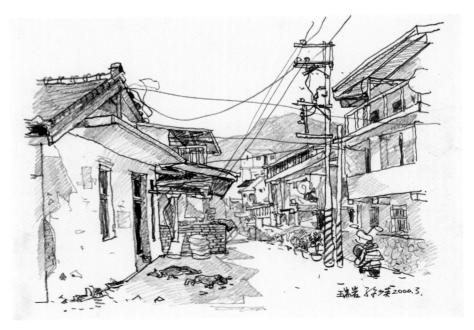

南投瑞岩 8開 鉛筆 2000

Ruiyan, Nantou 8K Pencil 2000

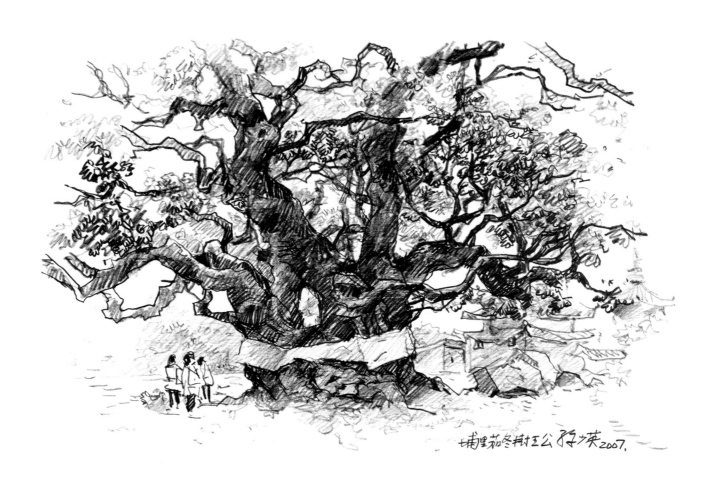

埔里茄冬樹王公　4開　鉛筆　2007
Tree God of Red Cedar, Puli　4K　Pencil　2007

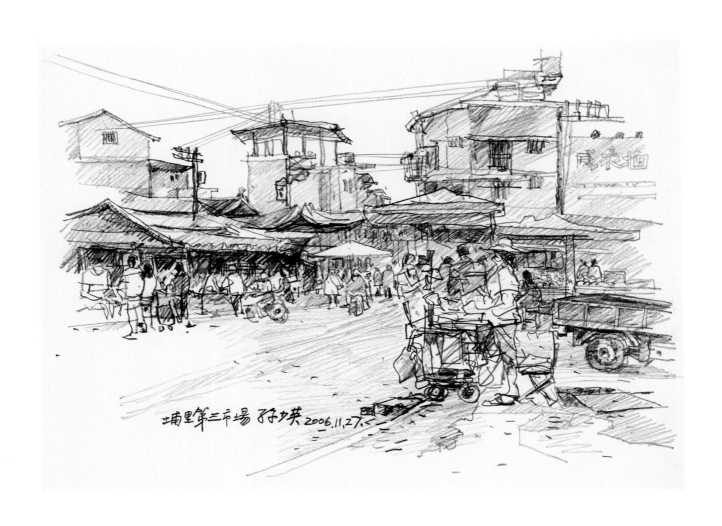

埔里第三市場　4開　鉛筆　2006
The Third Market, Puli　4K　Pencil　2006

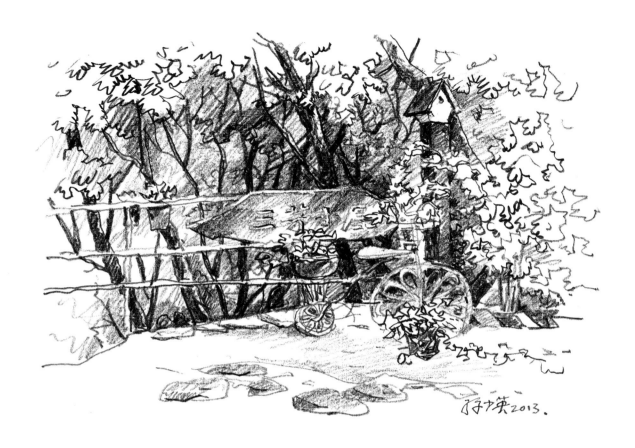

埔里三茅小屋　8開　鉛筆　2013
Sanmaowu, Puli　8K　Pencil　2013

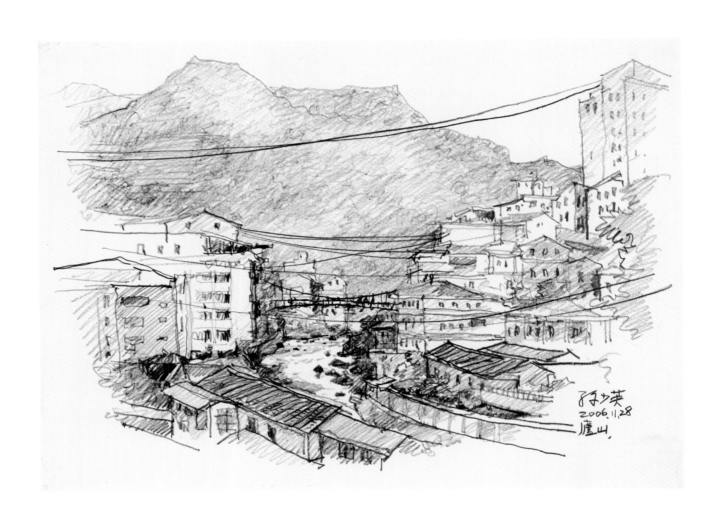

廬山 4開 鉛筆 2006
Lushan 4K Pencil 2006

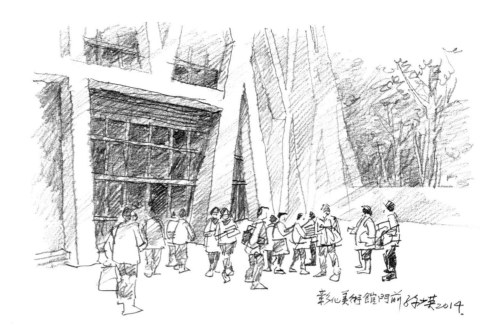

彰化美術館門前　8開　鉛筆　2014
In Front of Changhua Arts Museum　8K　Pencil　2014

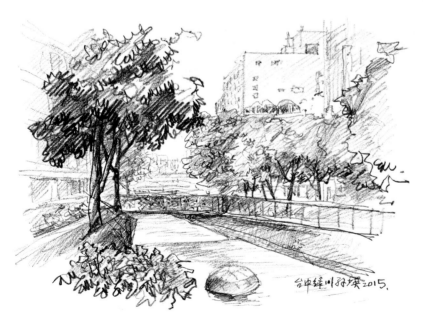

台中綠川　8開　鉛筆　2015
Luchuan, Taichung　8K　Pencil　2015

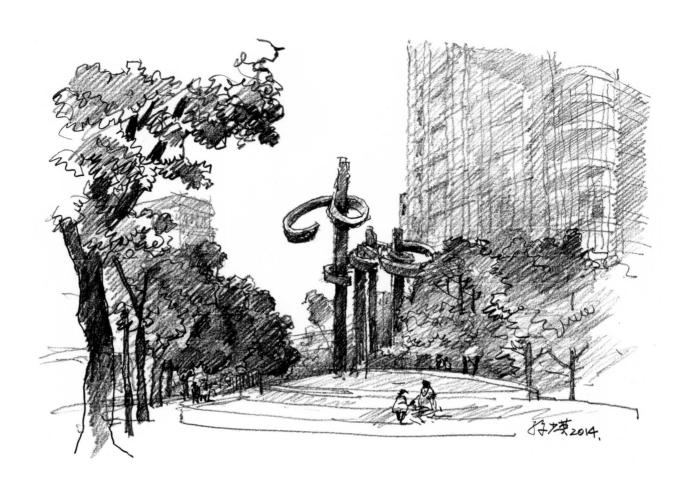

台中草悟道　4開　鉛筆　2014
Calligraphy Greenway, Taichung 4K Pencil 2014

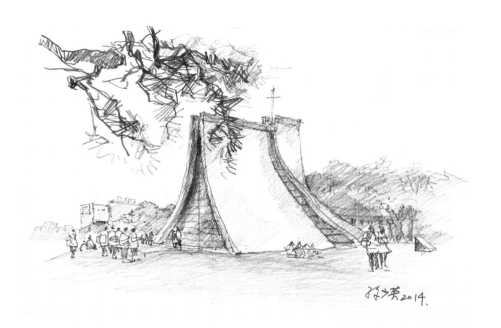

東海路思義教堂 8開 鉛筆 2014
Luce Memorial Chapel, Tunghai University 8K Pencil 2014

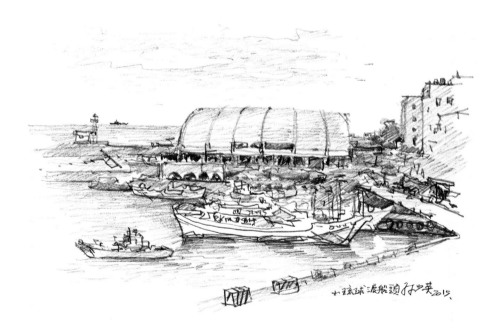

小琉球渡船頭 8開 鉛筆 2015
Ferry Port, Liuqiu 8K Pencil 2015

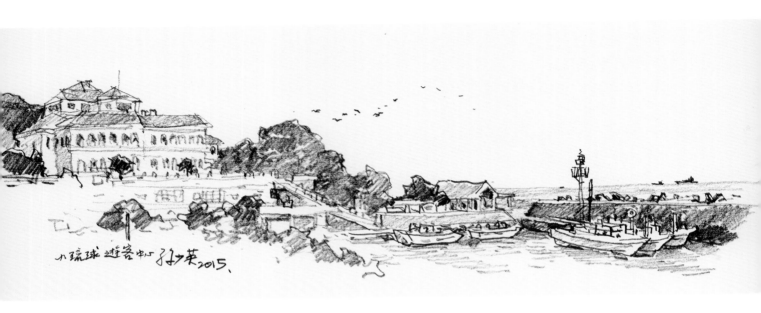

小琉球遊客中心　8開　鉛筆　2015
Tourist Center, Liuqiu　8K　Pencil　2015

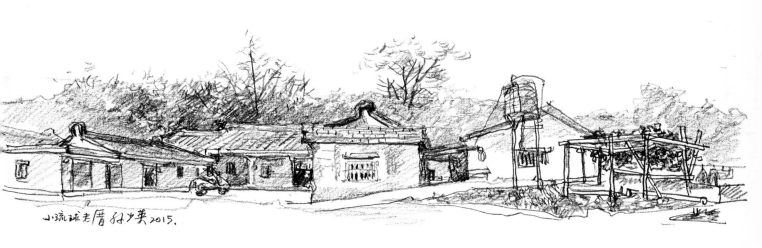

小琉球老厝 8開 鉛筆 2015
Old House, Liuqiu 8K Pencil 2015

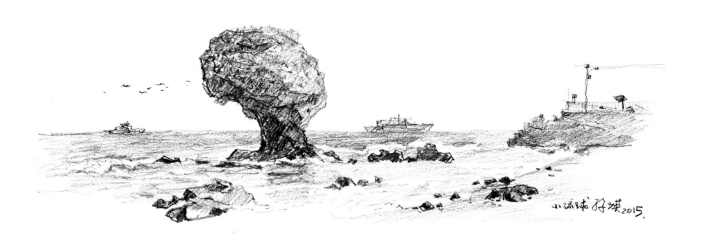

小琉球海岸岩石 8開 鉛筆 2015
Coastal Rocks, Liuqiu 8K Pencil 2015

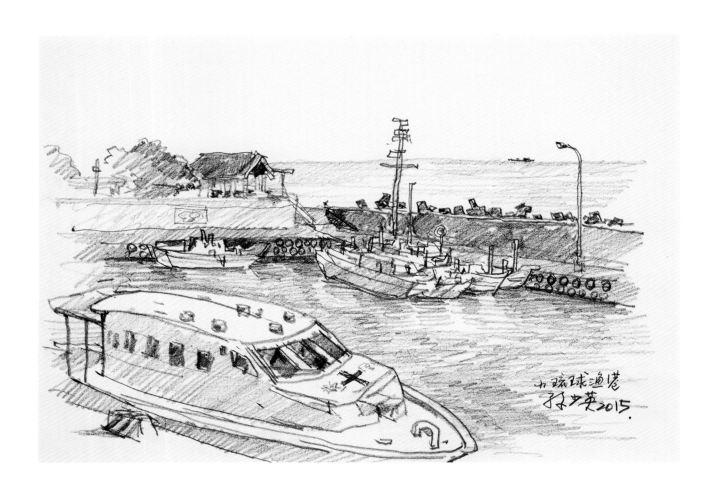

小琉球漁港（一）　8開　鉛筆　2015
Fishing Port, Liuqiu (I) 8K Pencil 2015

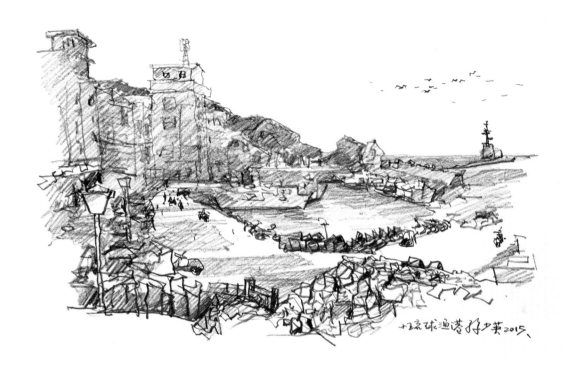

小琉球漁港（二） 8開 鉛筆 2015
Fishing Port, Liuqiu (II) 8K Pencil 2015

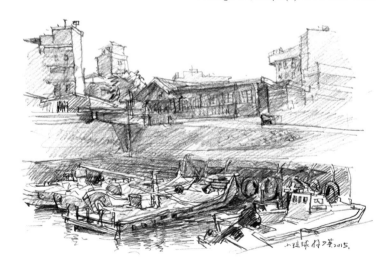

小琉球漁港（三） 8開 鉛筆 2015
Fishing Port, Liuqiu (III) 8K Pencil 2015

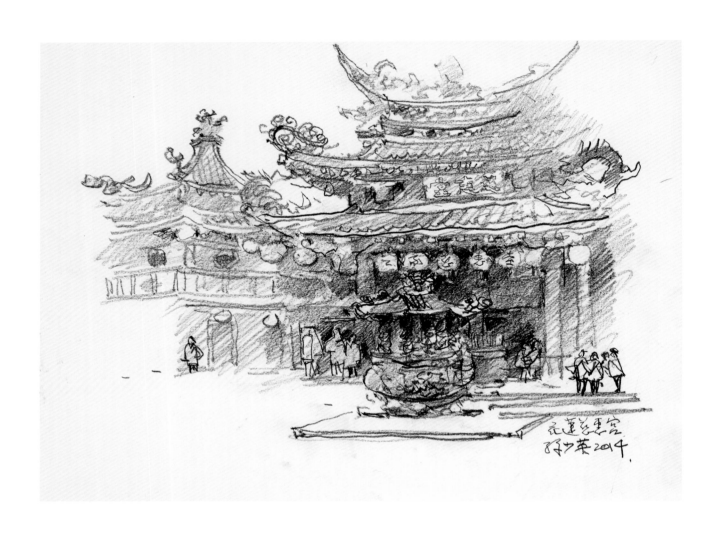

花蓮廟宇（一）8開 鉛筆 2014

Temple, Hualien (I) 8K Pencil 2014

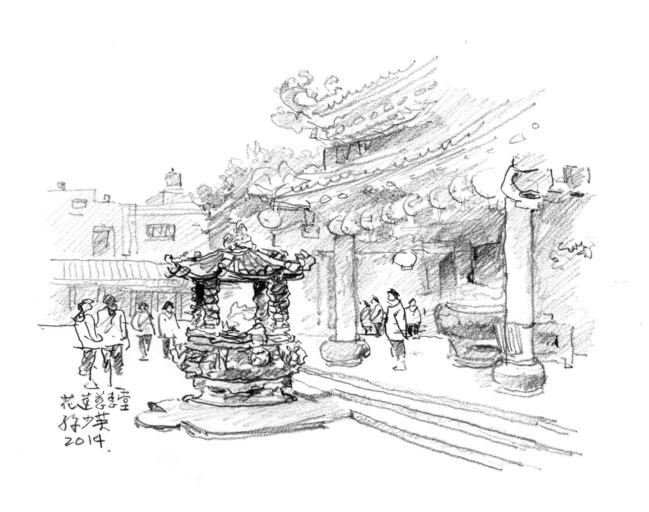

花蓮廟宇（二） 8開 鉛筆 2014
Temple, Hualien (II) 8K Pencil 2014

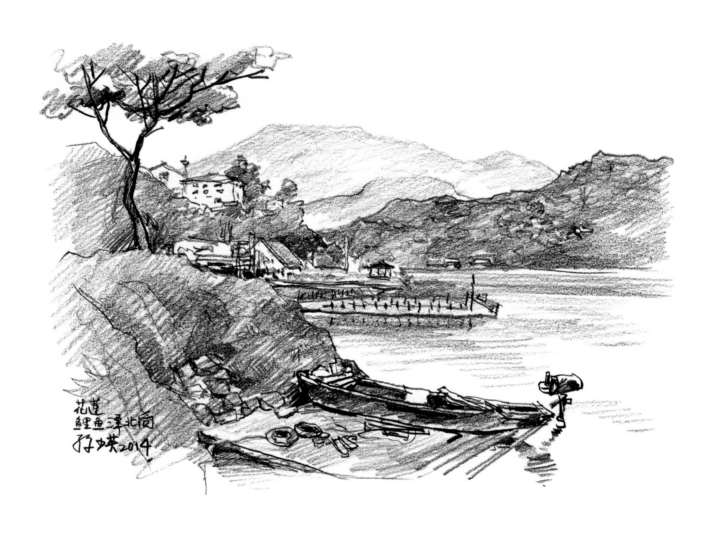

花蓮鯉魚潭　8開　鉛筆　2014
Liyu Lake, Hualien　8K　Pencil　2014

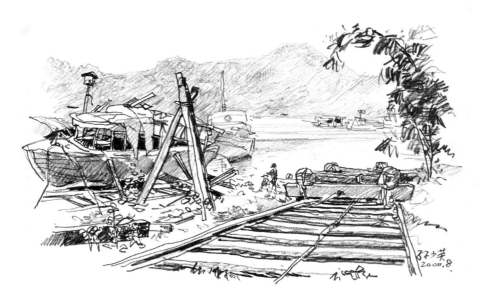

日月潭修船塢　8開　鉛筆　2000
Repair Dock, Sun Moon Lake　8K　Pencil　2000

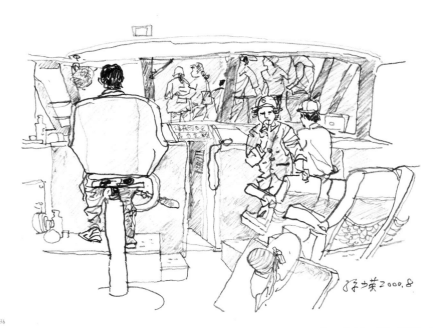

日月潭遊艇內景　8開　鉛筆　2000
Interior of A Yacht, Sun Moon Lake　8K　Pencil　2000

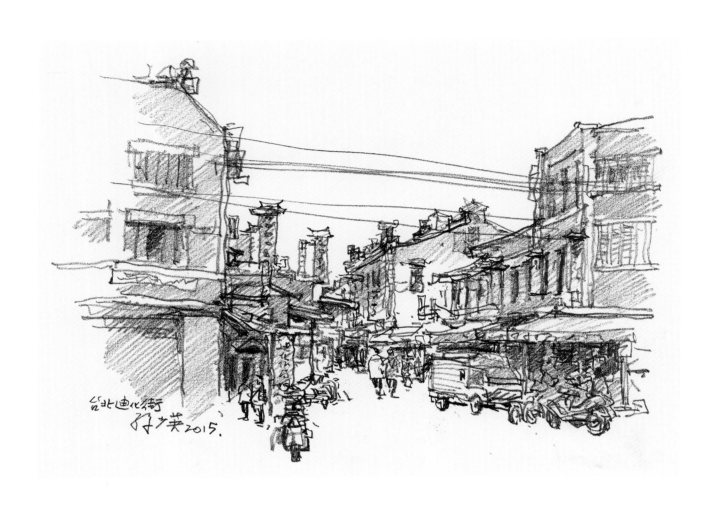

台北迪化街　8開　鉛筆　2015
Dihua Street, Taipei 8K Pencil 2015

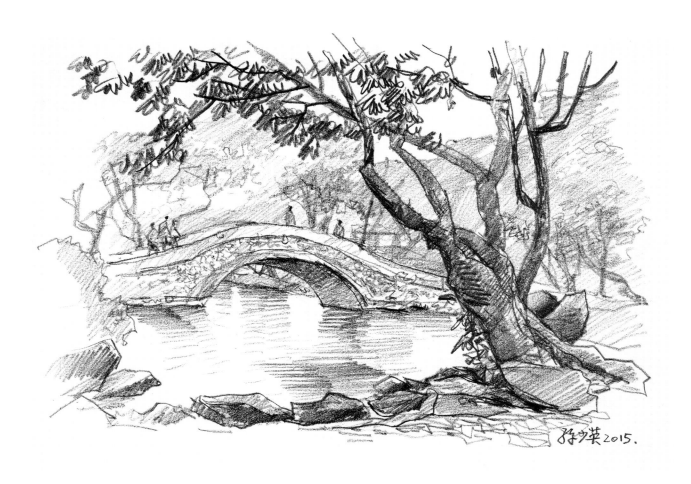

台北二二八紀念公園　8開　鉛筆　2015
The 228 Peace Memorial Park, Taipei　8K　Pencil　2015

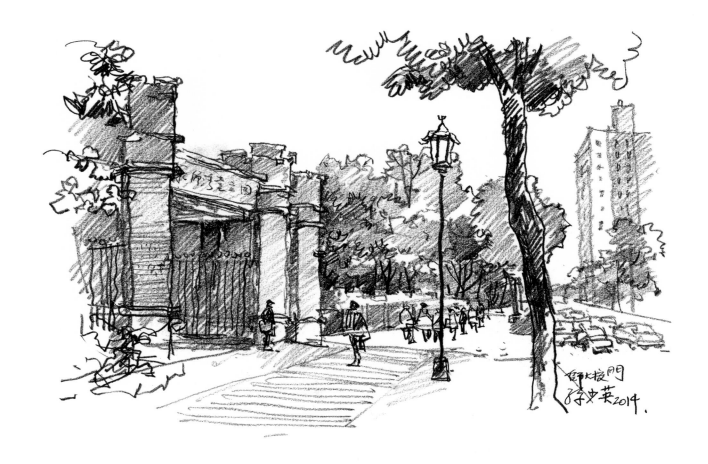

台北師範大學　8開　鉛筆　2014
National Taiwan Normal University, Taipei　8K　Pencil　2014

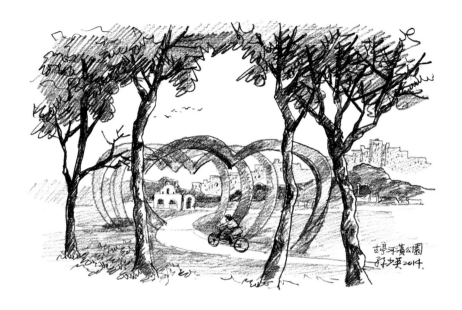

台北古亭河濱公園（一） 4開 鉛筆 2014
Guting Riverside Park, Taipei (I) 4K Pencil 2014

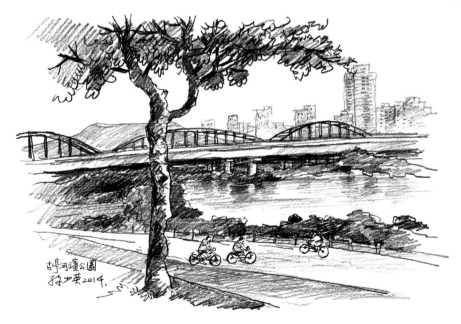

台北古亭河濱公園（二） 4開 鉛筆 2014
Guting Riverside Park, Taipei (II) 4K Pencil 2014

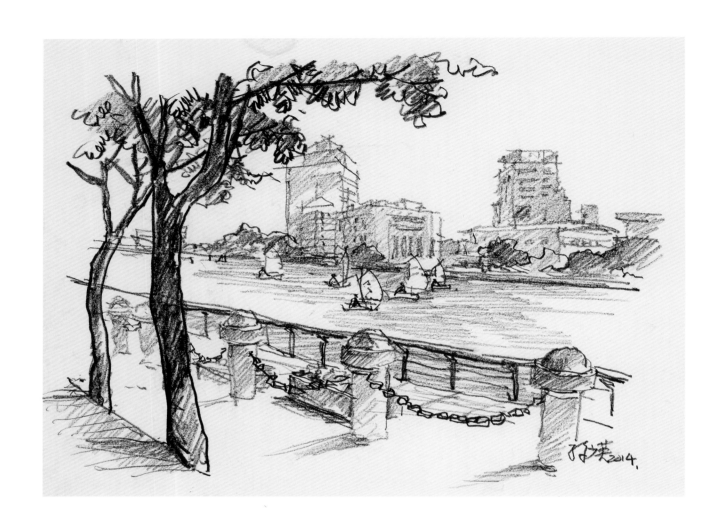

高雄愛河風光　8開　鉛筆　2014
Lover River Scenery, Kaohsiung　8K　Pencil　2014

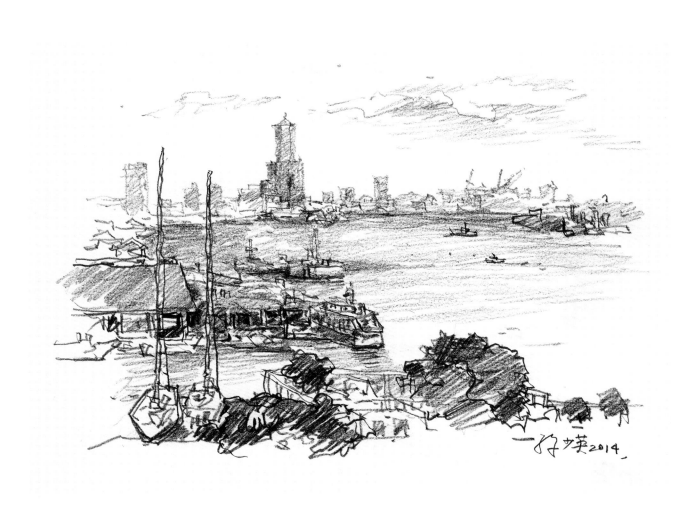

高雄港（一） 8開 鉛筆 2014
Port of Kaohsiung (I) 8K Pencil 2014

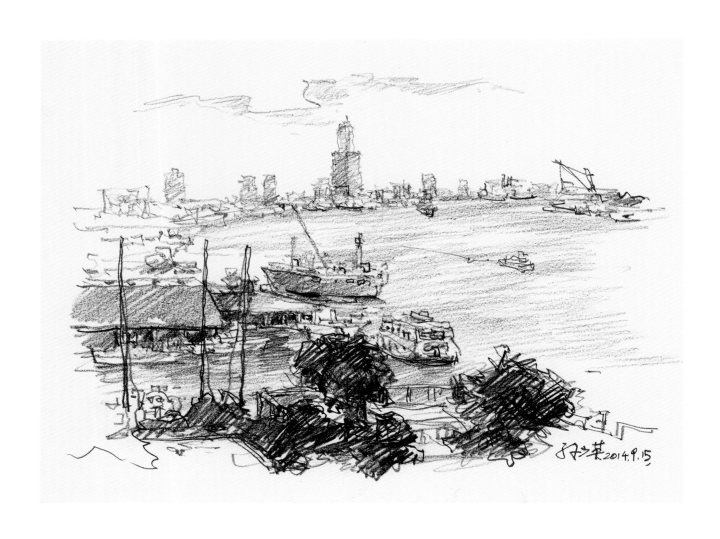

高雄港（二） 8開 鉛筆 2014
Port of Kaohsiung (II) 8K Pencil 2014

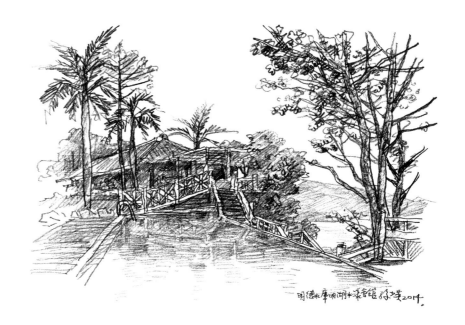

明德水庫（一） 4開 鉛筆 2014
Mingde Reservoir (I) 4K Pencil 2014

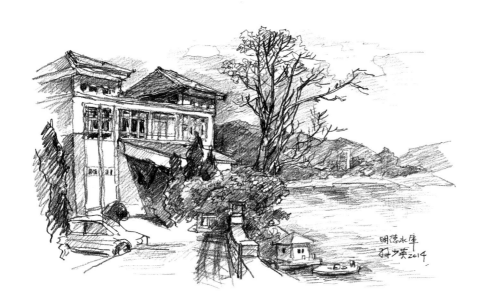

明德水庫（二） 4開 鉛筆 2014
Mingde Reservoir (II) 4K Pencil 2014

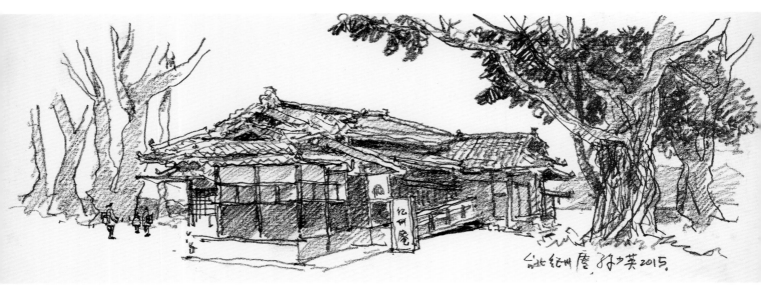

台北紀州庵（一）　8開　鉛筆　2015
Kishu An, Taipei (I)　8K　Pencil　2015

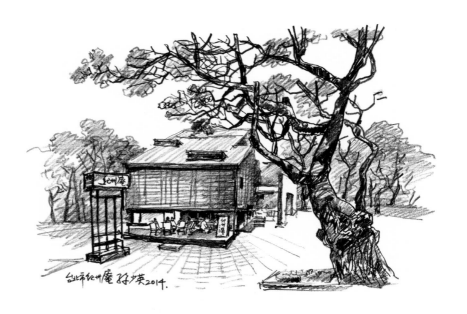

台北紀州庵（二）　4開　鉛筆　2014
Kishu An, Taipei (II)　4K　Pencil　2014

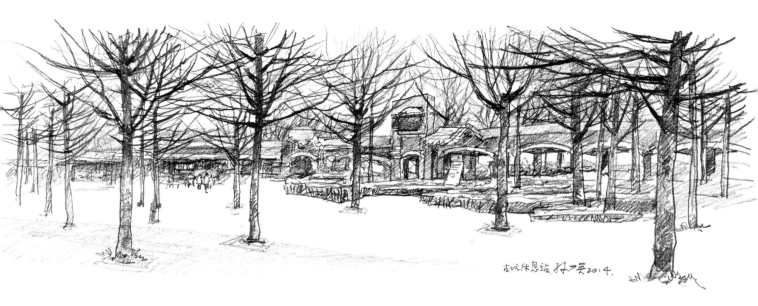

古坑休息站（一）4開 鉛筆 2014
Gukeng Service Area (I) 4K Pencil 2014

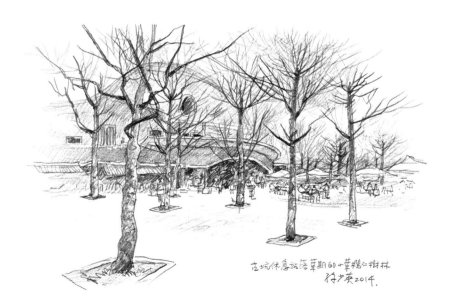

古坑休息站（二）4開 鉛筆 2014
Gukeng Service Area (II) 4K Pencil 2014

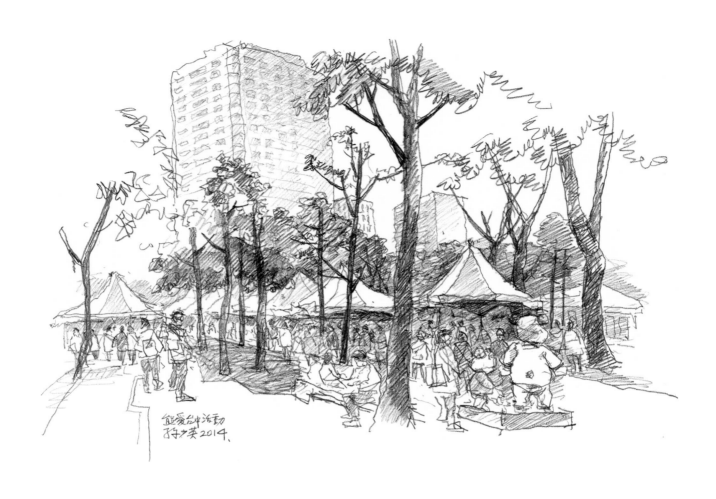

熊愛台中活動（一） 2開 鉛筆 2014
Teddy Bear Lohas Carnival at Taichung (I) 2K Pencil 2014

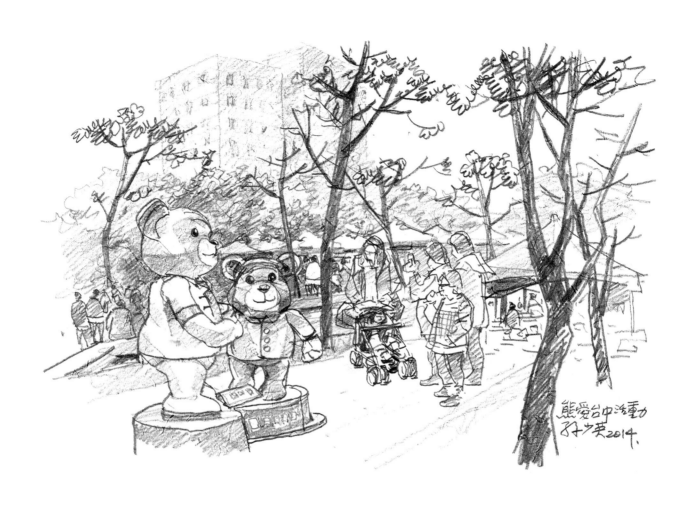

熊愛台中活動（二） 4開 鉛筆 2014
Teddy Bear Lohas Carnival at Taichung (II) 4K Pencil 2014

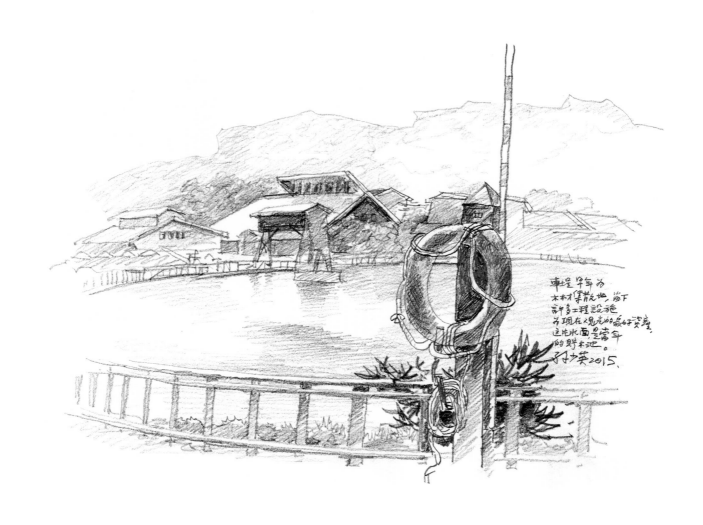

車埕早年為
木材聚散地，當下
許多工程設施
子現在又見光的最好見證，
這片水面，是當年
的貯木池。

林文英 2015.

車埕貯木池 4開 鉛筆 2015
Log Pond, Checheng 4K Pencil 2015

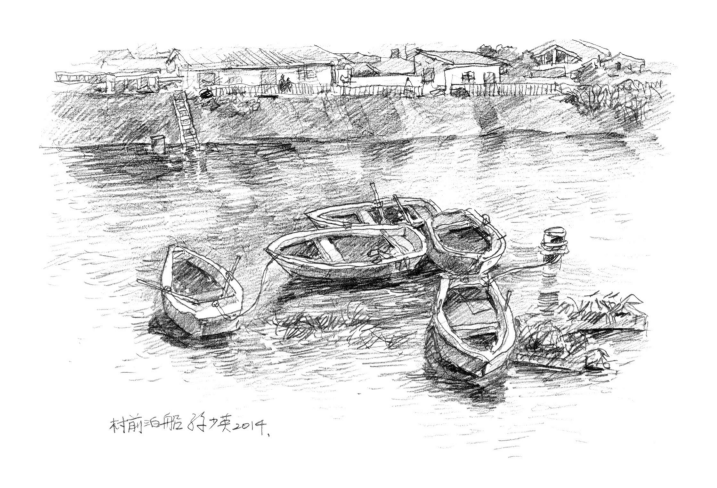

村前泊船 好璞 2014,

日月潭村前泊船　4開　鉛筆　2014
Docked Boats in Front of the Village, Sun Moon Lake　4K　Pencil　2014

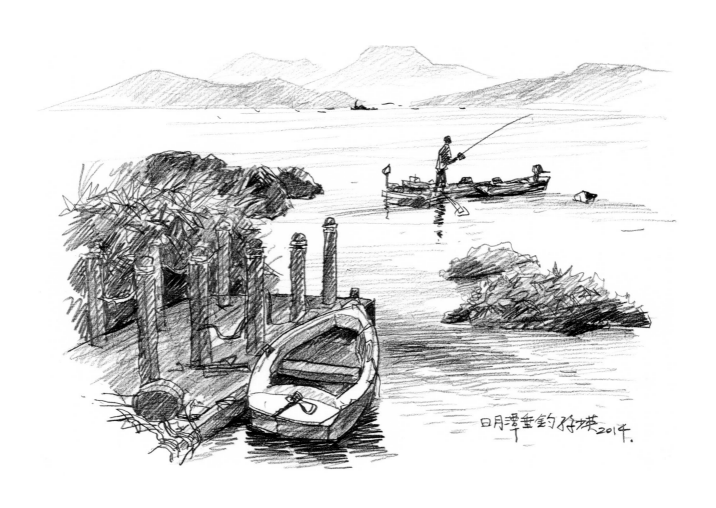

日月潭垂釣　4開　鉛筆　2014
Fishing, Sun Moon Lake　4K　Pencil　2014

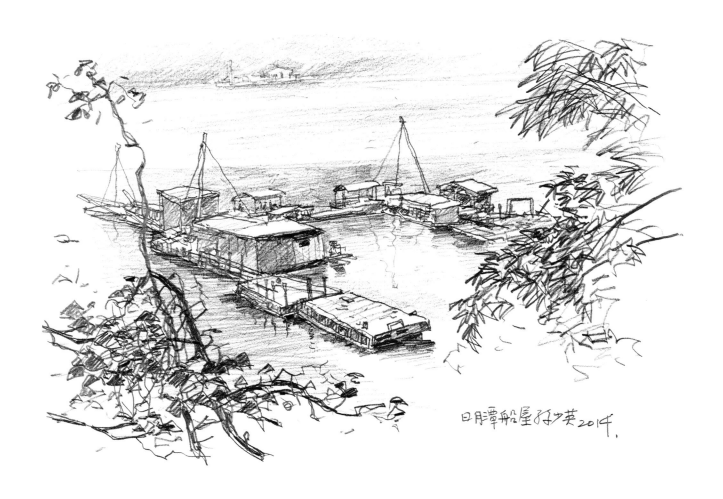

日月潭船屋 4開 鉛筆 2014
Boat House, Sun Moon Lake 4K Pencil 2014

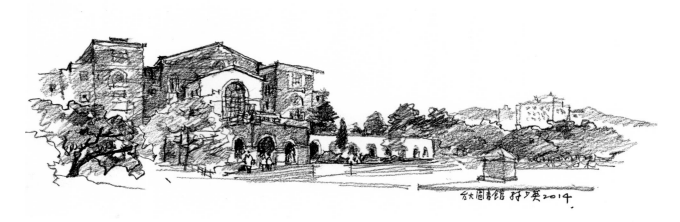

台大圖書館　8開　鉛筆　2014

National Taiwan University Library　8K　Pencil　2014

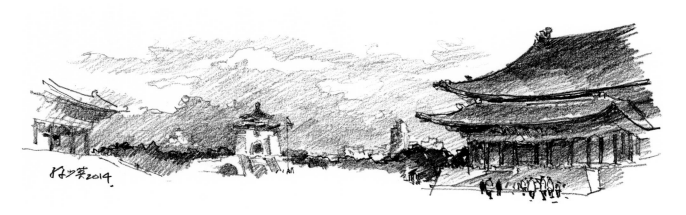

中正紀念堂　8開　鉛筆　2014

National Chiang Kai-Shek Memorial Hall　8K　Pencil　2014

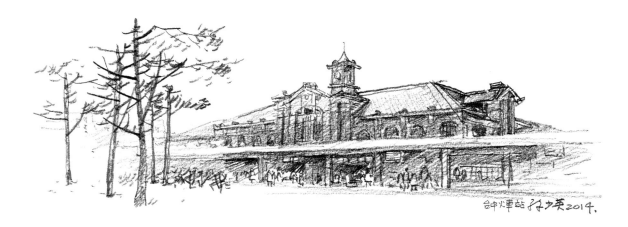

台中火車站 8開 鉛筆 2014
Taichung Station 8K Pencil 2014

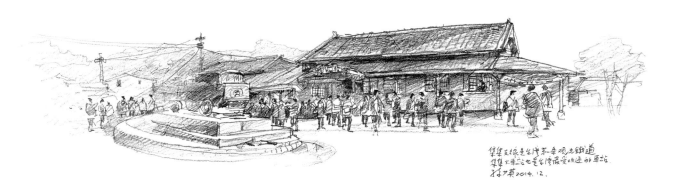

集集火車站 4開 鉛筆 2014
Jiji Station 4K Pencil 2014

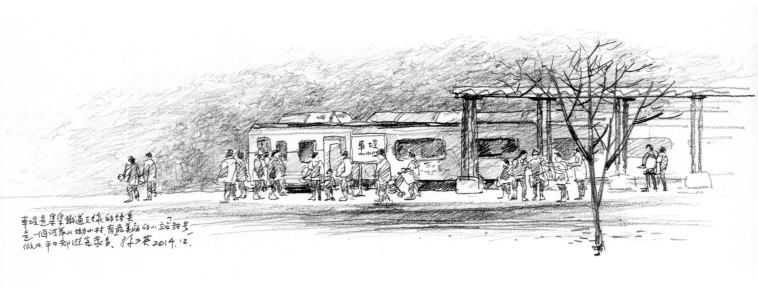

車埕是集集鐵道支線的終美
是一個河谷山坳小村,有最美麗的小站我是
假日,平日都遊客眾多.林少英 2014.12.

車埕鐵道支線 4開 鉛筆 2014
Railway Branch, Checheng 4K Pencil 2014

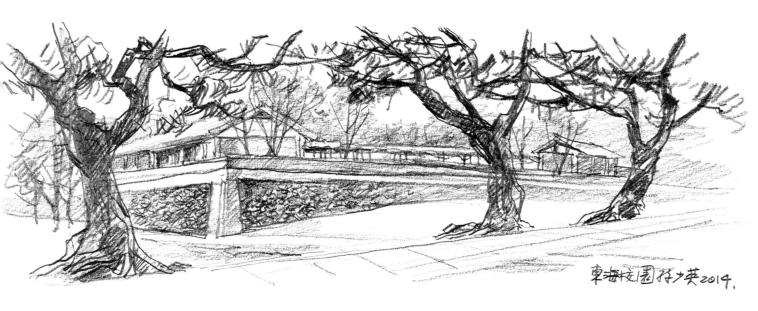

東海校園　8開　鉛筆　2014
Tunghai University Campus 8K　Pencil　2014

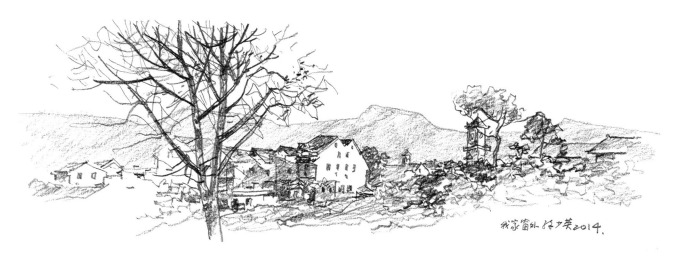

我家窗外　8開　鉛筆　2014
View Outside My Window 8K　Pencil　2014

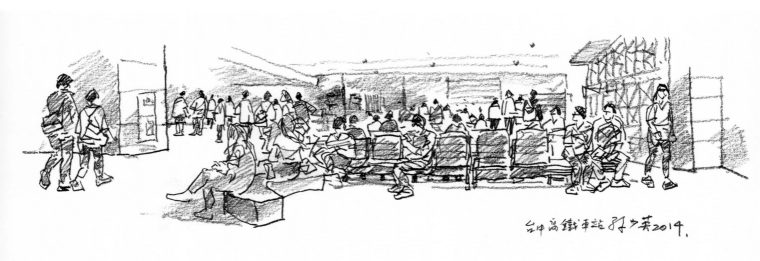

台中高鐵車站　8開　鉛筆　2014
Taiwan High Speed Rail Taichung Station　8K　Pencil　2014

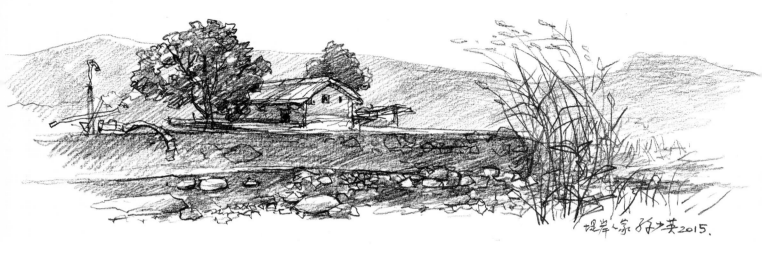

埔里堤岸人家　8開　鉛筆　2015
Houses on the Embankment, Puli 8K Pencil 2015

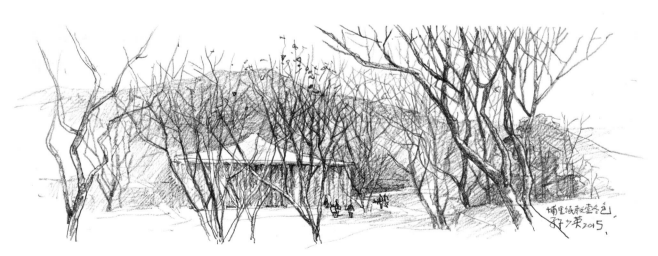

埔里紙教堂冬色　8開　鉛筆　2015
A Winter Scene at Paper Dome, Puli 8K Pencil 2015

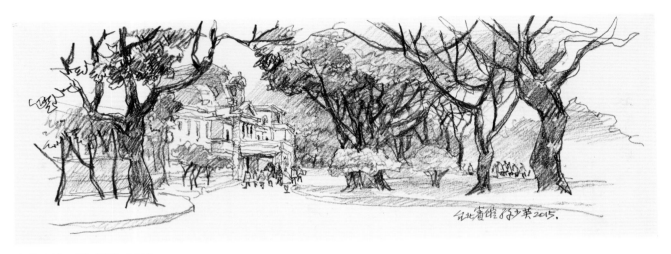

台北賓館 8開 鉛筆 2015
Taipei Guest House 8K Pencil 2015

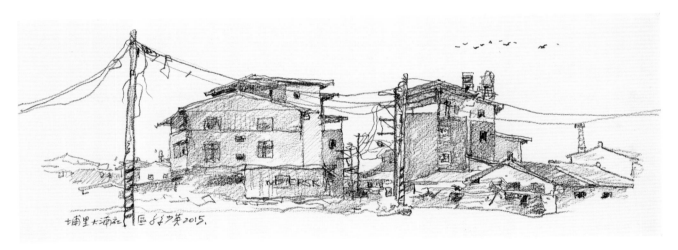

埔里大湳社區 8開 鉛筆 2015
Danan Community, Puli 8K Pencil 2015

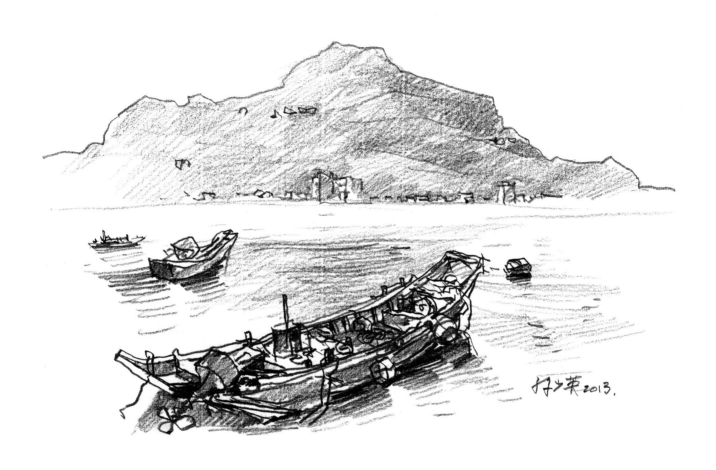

淡水河畔（一） 8開 鉛筆 2013
Tamsui River Shore (I) 8K Pencil 2013

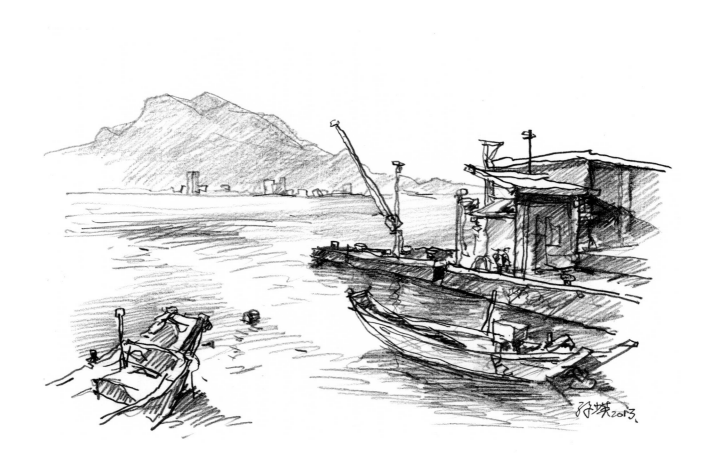

淡水河畔（二） 8開 鉛筆 2013
Tamsui River Shore (II) 8K Pencil 2013

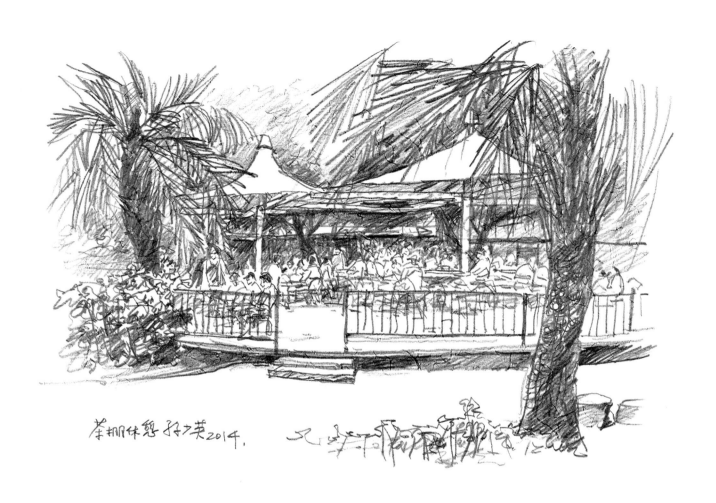

茶棚休憩 招力英 2014.

國父紀念館茶棚 4開 鉛筆 2014
Tea Pavilion at Dr. Sun Yat-Sen Memorial Hall 4K Pencil 2014

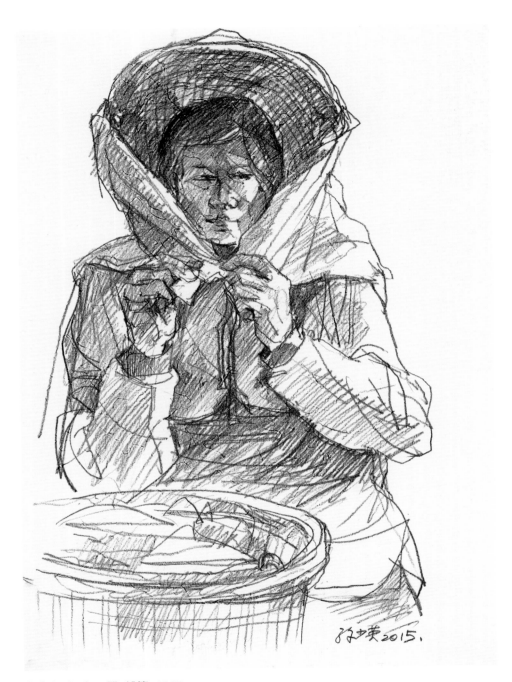

農家女（一） 4開 鉛筆 2015
Farmer Girl (I) 4K Pencil 2015

農家女（二） 4開 鉛筆 2015
Farmer Girl (II) 4K Pencil 2015

農家女（三） 4開 鉛筆 2014
Farmer Girl (III) 4K Pencil 2014

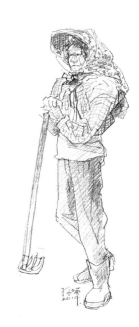

農家女（四） 4開 鉛筆 2014
Farmer Girl (IV) 4K Pencil 2014

農家女（五） 4開 鉛筆 2014
Farmer Girl (V) 4K Pencil 2014

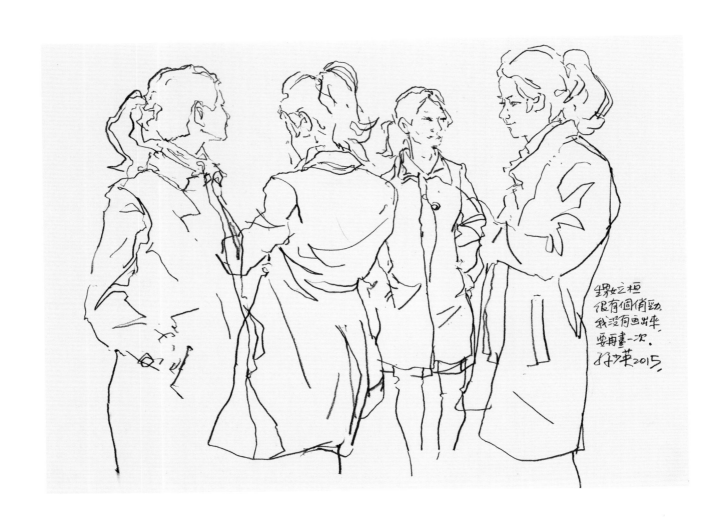

少女姿態 4開 鉛筆 2015
Pose of A Young Girl 4K Pencil 2015

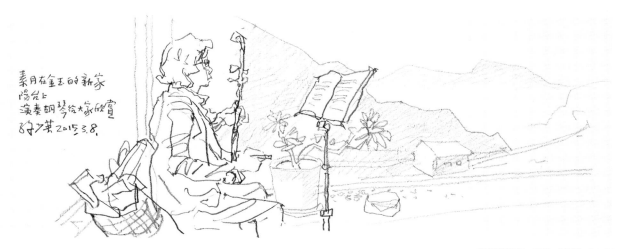

素月在金玉的新家
陽台上
演奏胡琴给大家欣賞
何少荣 2015.3.8.

胡琴演奏 8開 鉛筆 2015
Huqin Performance 8K Pencil 2015

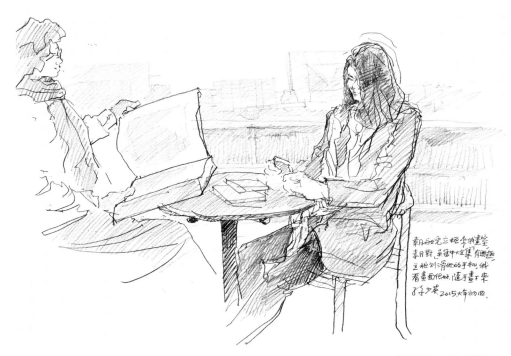

朝雨女兒立柜�‧推畫堂
素月對吳蓴中大全筆有興趣
主要刻劃她的手机 斜
看畫面很好,隨手畫下來
何少荣 2015大年初四.

玩手機 2開 鉛筆 2015
Playing on the Mobile Phone 2K Pencil 2015

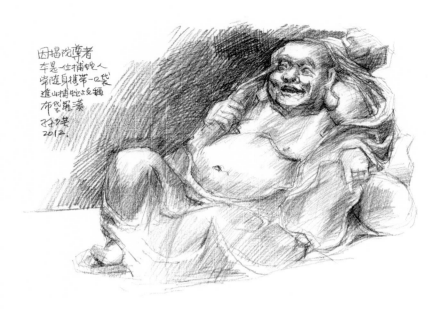

布袋羅漢 2開 鉛筆 2012
Calico Bag Luohan 2K Pencil 2012

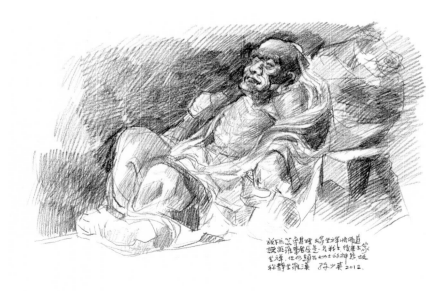

靜坐羅漢 2開 鉛筆 2012
Meditating Luohan 2K Pencil 2012

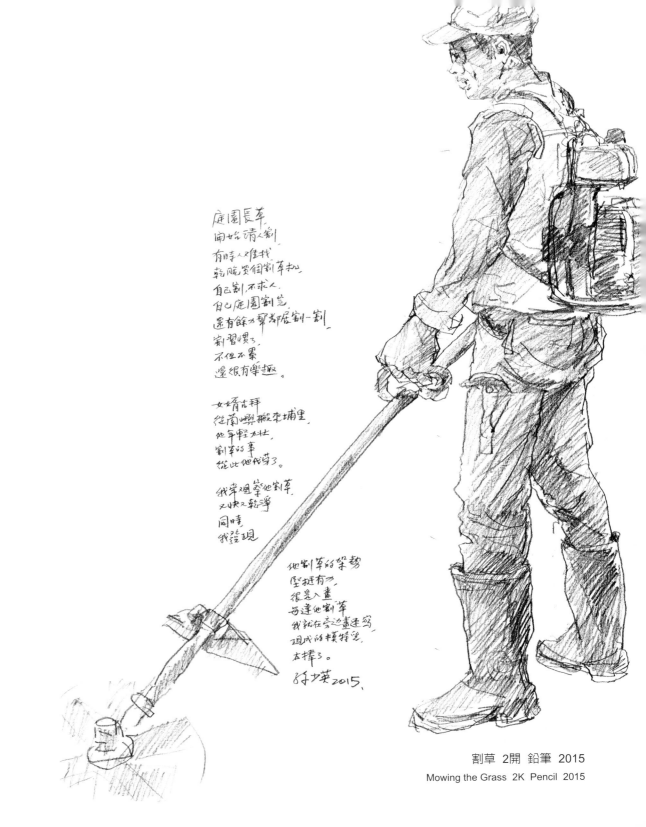

庭園長草
開始請人割
有時人難找
乾脆買個割草機
自己割，不求人。
自己庭園割完
還有餘力鄰居割一割
割習慣了
不但不累
還很有樂趣。

女婿志拜
從南嶼搬來埔里
他年輕力壯
割草的事
從此他代勞了。

我常觀察他割草
又快又乾淨
同時
我發現

他割草的架勢
挺挺有力
很是入畫
每逢他割草
我就在旁邊畫速寫
現成的模特兒
太棒了。

好珠2015.

割草 2開 鉛筆 2015
Mowing the Grass 2K Pencil 2015

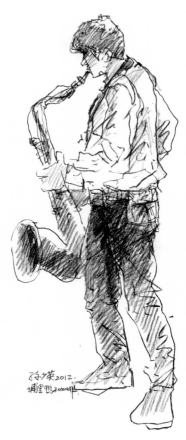

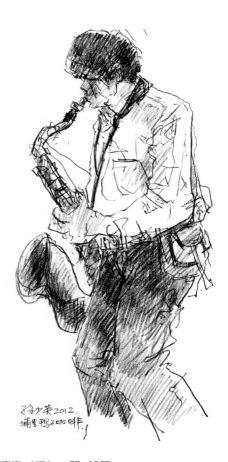

薩克斯風演奏（一） 2開 鉛筆 2012
Saxophone Performance (I) 2K Pencil 2012

薩克斯風演奏（二） 2開 鉛筆 2012
Saxophone Performance (II) 2K Pencil 2012

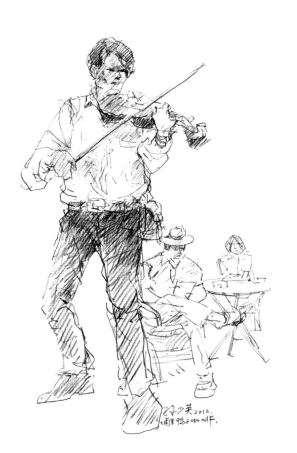

小提琴演奏 2開 鉛筆 2012
Violin Performance 2K Pencil 2012

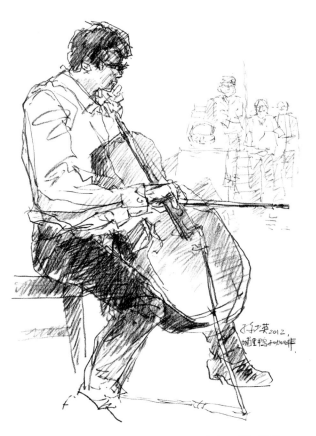

大提琴演奏 2開 鉛筆 2012
Cello Performance 2K Pencil 2012

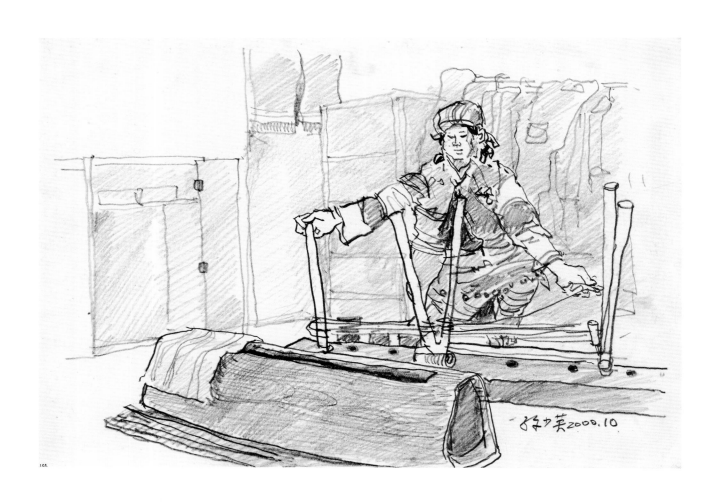

春陽原住民織布　8開　鉛筆　2000
Weaving Indigene, Chunyan 8K Pencil 2000

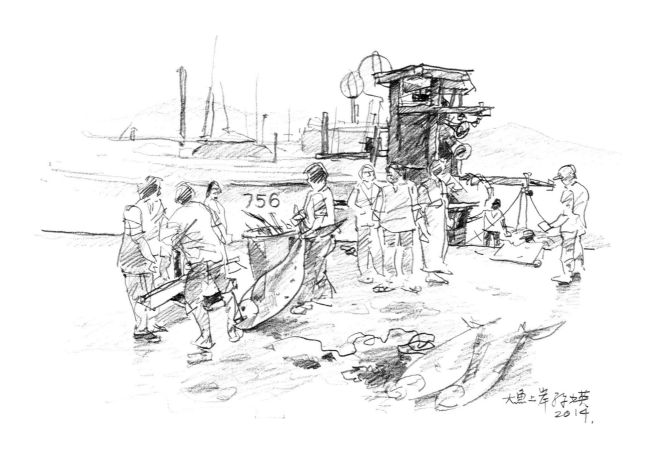

756

大魚上岸 4開 鉛筆 2014
Landing of Big Fishes 4K Pencil 2014

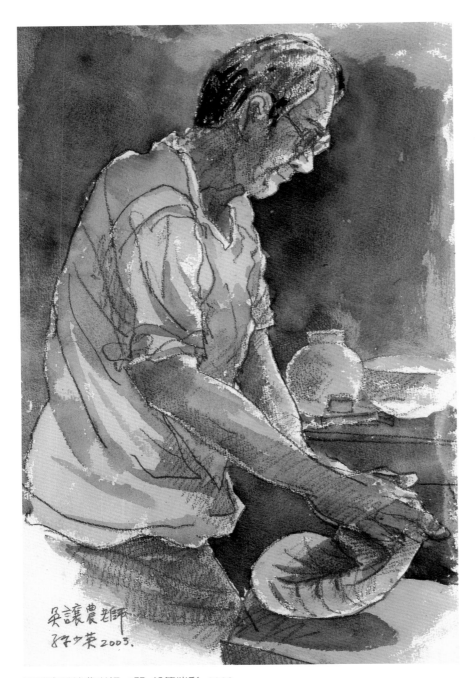

陶藝家吳讓農老師　4開　鉛筆淡彩　2003
Master Wu Rhang-Nung, Ceramic Artist　4K　Pencil-Outlined Wash Drawing　2003

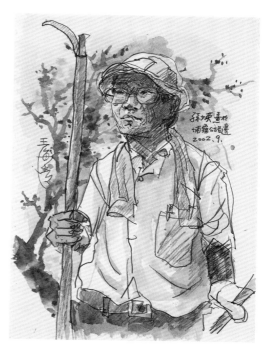

埔里櫻花老人王海清先生　4開　鉛筆淡彩　2002
Mr. Wang Hai-Ching, Senior Cherry Grower of Puli
4K　Pencil-Outlined Wash Drawing　2002

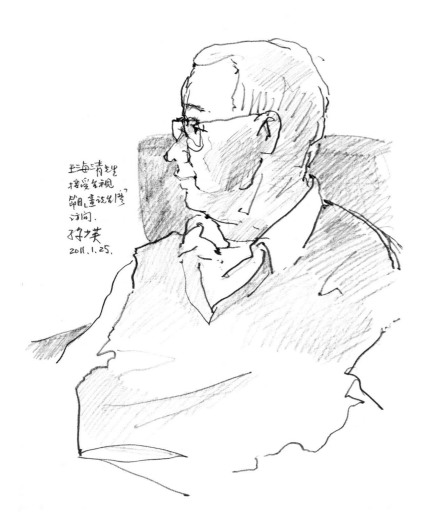

十年後的王海清先生　8開　鉛筆　2011
Mr. Wang Hai-Ching, A Decade Later　8K　Pencil　2011

人像速寫步驟圖解 Step-by-Step Figure Sketching Illustrations

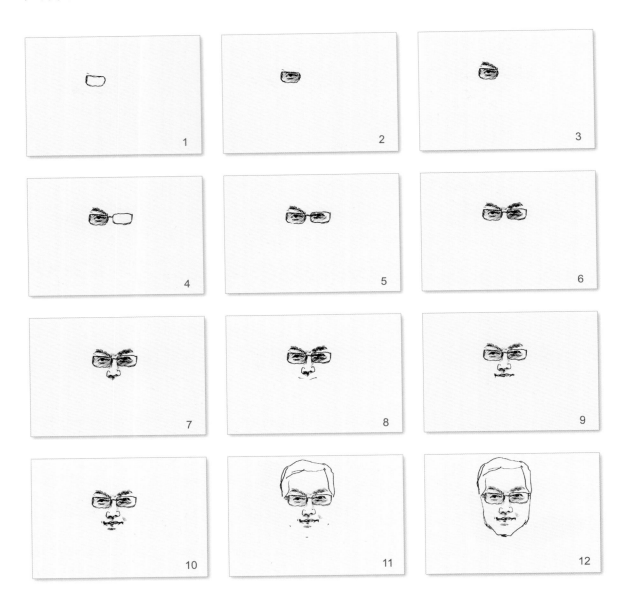

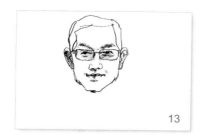

13

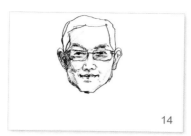

14

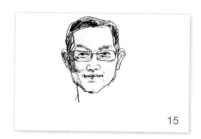

15

16

17

18

林耀堂教授照片
Photo of Professor Lin Yao-Tang

完成圖 Finished Work

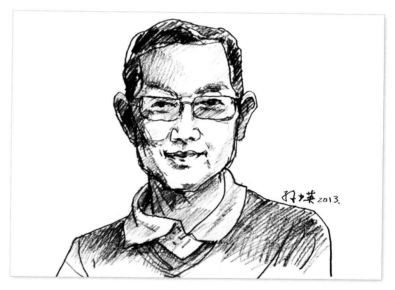

孫少英

感謝林耀堂教授同意用他的肖像做此「人像速寫步驟圖解」。

耀堂是數位版畫藝術的創始者，我們同為埔里人，平日對我繪事多所指導。

畫人像，我的經驗是盡量不要畫照片，因為照片畫慣了，會喪失創造能力，養成只會仿摹的毛病。

這組「人像速寫步驟圖解」是根據照片畫的，因為是為了製作方便。

我畫人像速寫或是風景寫生，我習慣的方法是從寫字的「筆順」聯想而來，寫任何字，人人都有相同的筆順，因為筆順是從共同的習慣中得出來的最順手、最方便、最合理的寫法。

畫人像或風景依筆順的觀念，從一點開始，就「近處」向外發展，是很容易精準和快速的方法。以這組步驟圖解為例，我先畫右眼鏡框，以鏡框為準再畫眼睛和眉毛，因為是「近處」著眼，像筆順一樣很容易把握，這樣從「近處」依序畫下去，像寫字一樣，幾乎不要太多思考時間，一幅人像幾分鐘就完成了。還有重要的是畫前一定要在紙張上虛擬人像大小位置，就是在腦子裡先有個輪廓草稿，根據這個虛擬草稿，決定開始的位置，我畫人像，通常都是從右眼開始。我這個習慣已久的方法，我名之曰：「一點延伸法」。

繪畫的朋友，如想進一步瞭解，需要我現場示範，請與盧安藝術公司連絡。

下面另外一組「風景寫生步驟圖解」也是依據我這個「一點延伸法」完成的。

I would like to express my gratitude to Professor Lin Yao-Tang for his kind permission to use his portrait to create this Step-by-Step Figure Sketching Illustrations.

Yao-Tang is the inventor of digital printmaking art. Both of us are from Puli. He constantly gives me guidance in my painting career.

For painting figures, I try not to draw from photographs as I have learned by experience. I may lose my creativity and become a habitual imitator if I get used to drawing from photographs.

This series of Step-by-Step Figure Sketching Illustrations was drawn after a photograph simply for the sake of convenient producing.

When I sketch figures or draw from nature, my habitual method has been derived from the "order of strokes" in writing. Everyone has similar order of strokes for writing each character, because the order of strokes in writing comes from the most effortless, convenient and reasonable way in our mutual habit.

The concept of drawing figures or landscapes following the order of strokes, which begins with one stroke and extends outwards from the "near ground," is a fairly precise and quick method. Take this series of step-by-step illustrations as an example, I firstly drew the right eyeglass frame to be a base and then worked on the eyes and eyebrows. Since I started with the "near ground," it was very easy for me to master the brushwork like the order of strokes. Just like writing, it almost required no consideration as I drew from the "near ground" to work in order, and then easily finished a figure sketch within a few minutes. And it is also important to virtually plan the size and location of the figure on the paper prior to drawing, which is like having a draft profile in the mind, and the starting point could be determined accordingly. I like to start with the right eye when I draw figures. I have named this method, my long-term habit, as One Stroke Extension.

For anyone who loves painting, if you like to understand further and need me to give a live demonstration, please contact the Luan Art Co., Ltd.

The following series of Step-by-Step Landscape Sketching Illustrations was also done according to my method of One Stroke Extension.

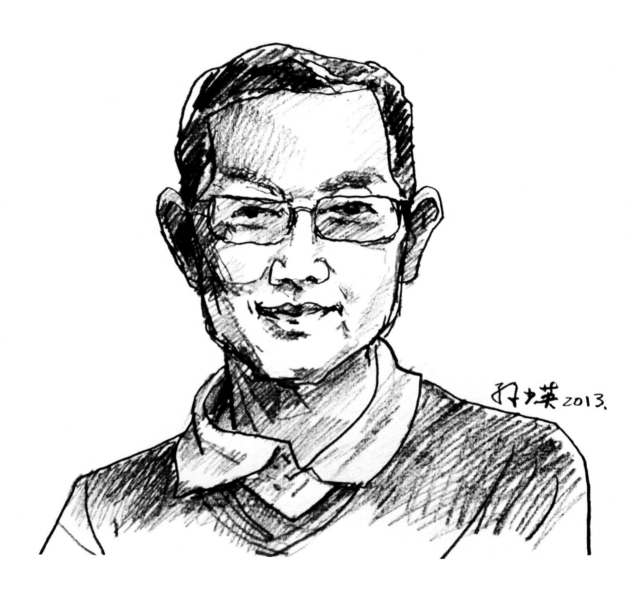

林耀堂教授 8開 鉛筆 2013
Professor Lin Yao-Tang 8K Pencil 2013

風景寫生步驟圖解 Step-by-Step Landscape Sketching Illustrations

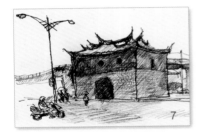

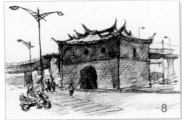

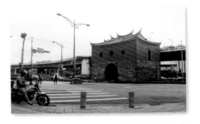

台北北門照片
Photo of North Gate, Taipei

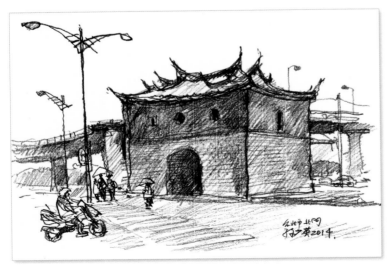

完成圖 Finished Work

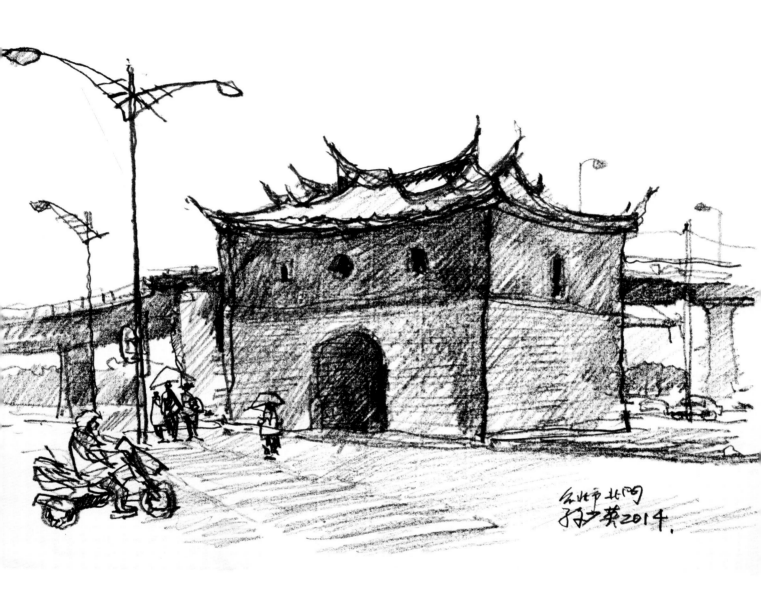

台北北門 8開 鉛筆 2014
North Gate, Taipei 8K Pencil 2014

九二一地震素描

　　民國88年九二一大地震，我住在災區埔里，災難過後，我以鉛筆素描畫下了一部份地震災難、救災以及重建的實況，這些素描在當時曾刊於多種報刊雜誌，並出版《九二一傷痕素描集》及《家園再造寫生集》兩書。同時曾有多種美術教科書引用我的素描做為教材。

　　我一百多幅地震素描原畫，承蒙九二一震災重建基金會賞識，已全部捐贈給台大圖書館收藏。

　　茲特選出4幅再次發表，藉以表示素描是繪畫藝術之外，也有其歷史記錄的功能。

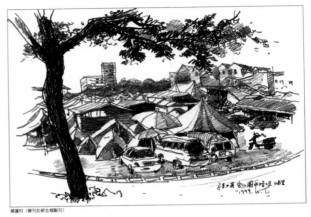

鄰蔭村（曾刊於新生報副刊）

大地震，震碎了多少人的家園。
埔里宏仁國中的大操場，搭起了各式各樣的順蓬，車子停在順蓬邊，車子上也可以住人。
宏仁國中的大操場平坦乾淨，大地震的當天，附近的居民在驚恐中，不約而同的都集中到了這塊空曠而沒有建物倒塌威脅的地方。
幸好天公作美，除了日前因颱風帶來了一陣小雨以外，其他地都還氣候宜人，假若遇日大雨，又逢震不斷，大家真不知如何是好。

Sketches of 921 Earthquake

　　When the 921 Earthquake occurred in 1999, I was living at Puli, a disaster-hit area. After the catastrophe, I sketched by pencil a few live scenes on the quake disaster, relief efforts and rebuilding. These sketches had been presented in several newspapers and magazines at that time, which have been compiled into two publications: *The Scars of 921* and *Rebuilding Our Homeland*. Meanwhile, many art textbooks have also adopted my sketches as teaching materials.

　　I am most grateful that all my original works of a hundred more earthquake sketches have already been donated to the collection of National Taiwan University Library by the 921 Earthquake Relief Foundation.

　　I hereby specially select four sketches to be presented again, in order to reveal the function of sketching as historical documentation in addition to an art of painting.

埔里酒廠儲酒庫（曾刊於聯合報副刊）

已有八十三年歷史的酒廠，這次地震受創極為嚴重，機座儲酒大槽被震得搖搖欲墜，陳年紹興流溢滿地，酒香飄散到好遠好遠的街道上。
屋漏偏逢連夜雨，三月裡酒廠又遭逢了一場祝融之災，二度傷害，似乎沒有剩酒廠擊倒，四月起，酒廠已恢復生產，著名的埔里紹興酒及愛蘭白酒再度上市。

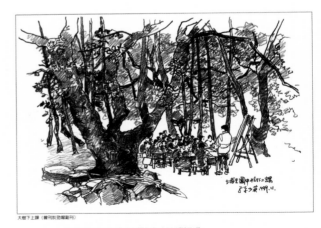

大樹下上課（曾刊於聯報副刊）

埔里國中的教室全毀，學生們有的在順蓬裡上課，有的在大樹底下上課。
在樹下上課，學生的桌椅要隨著大樹的陰影移動，上午坐西邊，下午坐東邊，中午則靠近大樹成不規則的，一天移動數次，孩子們倒覺得蠻有趣味。

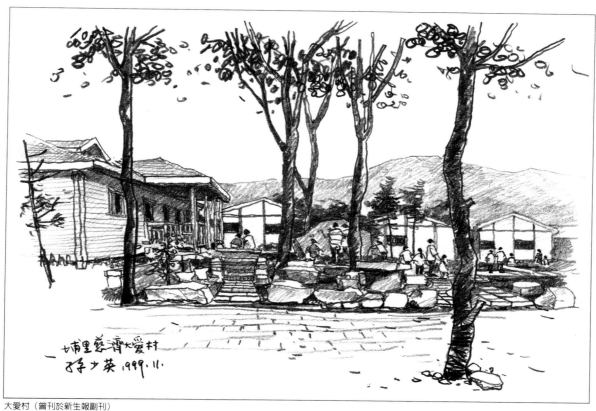

大愛村（曾刊於新生報副刊）

　　埔里慈濟組合屋完工了，定名為大愛村。

　　組合屋的中心地帶，蓋了一間漂亮的木屋，做為災民的休閒中心。木屋前有寬敞的草坪、高聳的大樹、整齊的步道、巨石雕刻、應時花木、大理石桌凳，還有數叢修竹。慈濟人為災民付出的心力，處處可見。假日附近居民，外來遊客，都聚集這裡參觀、休憩。

　　住戶林先生說：慈濟不但把庭園做得這麼好，每家的家具用品都準備得非常齊全，如廚具、冰箱、電視、熱水器、床舖、信箱等，真可說是無微不至。林先生還說：這是一份關懷、一份大愛，這種大愛才真正是社會安定、和諧、進步的動力。

炭精筆素描

這種筆跟鉛筆最大的不同是有相當的黑度，用力畫幾乎跟墨汁一樣，輕輕畫仍有理想的灰色階層。

請參閱第14頁〈我追求的素描趣味〉一文

Charcoal Pencil Sketch

It is most different from pencils in its considerable degree of blackness. It is nearly effective as ink when applied forcefully, yet it can still produce proper gradations of gray in lighter strokes.

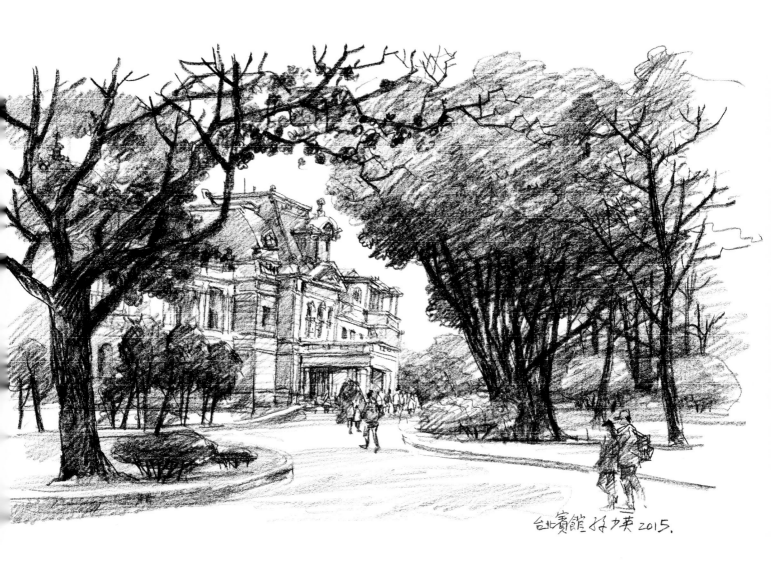

台北賓館 好英 2015.

台北賓館　2開　炭精筆　2015
Taipei Guest House　2K　Charcoal Pencil　2015

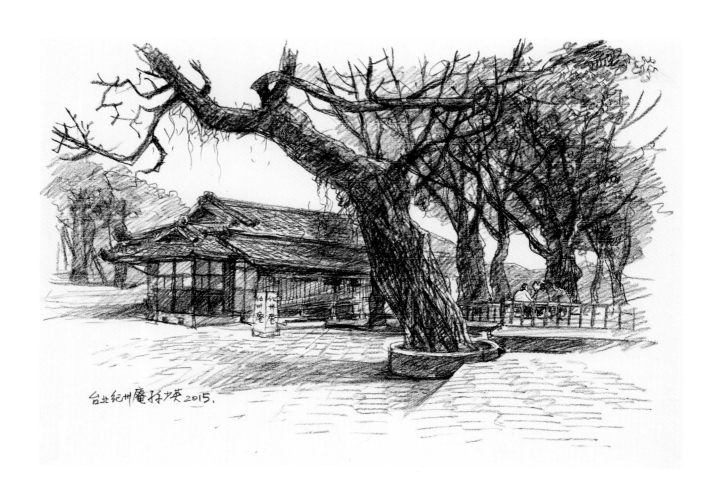

台北紀州庵 2開 炭精筆 2015
Kishu An, Taipei 2K Charcoal Pencil 2015

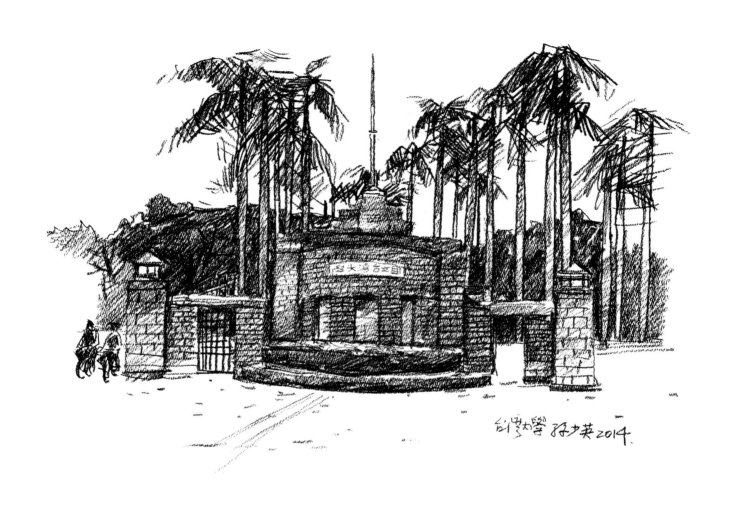

台灣大學校門　4開　炭精筆　2014
Main Gate of National Taiwan University　4K　Charcoal Pencil　2014

95

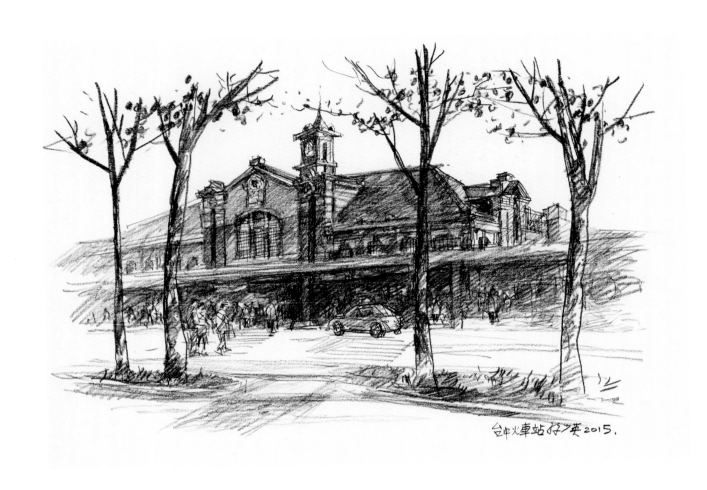

台中火車站 2開 炭精筆 2015
Taichung Station 2K Charcoal Pencil 2015

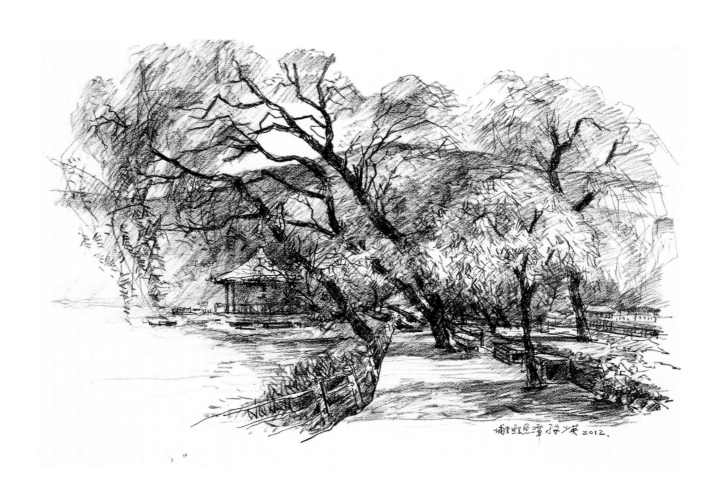

埔里鯉魚潭　2開　炭精筆　2012
Liyu Lake, Puli 2K Charcoal Pencil 2012

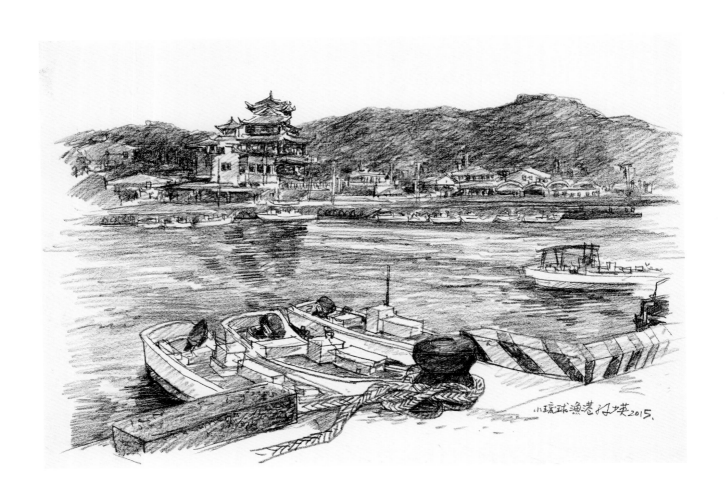

小琉球漁港　2開　炭精筆　2015
Fishing Port of Liuqiu 2K Charcoal Pencil 2015

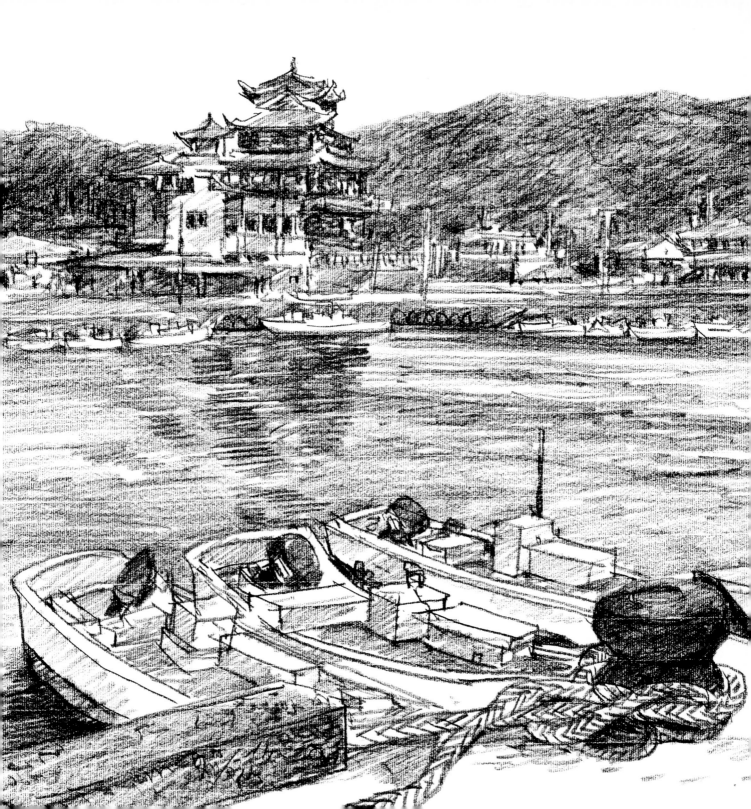

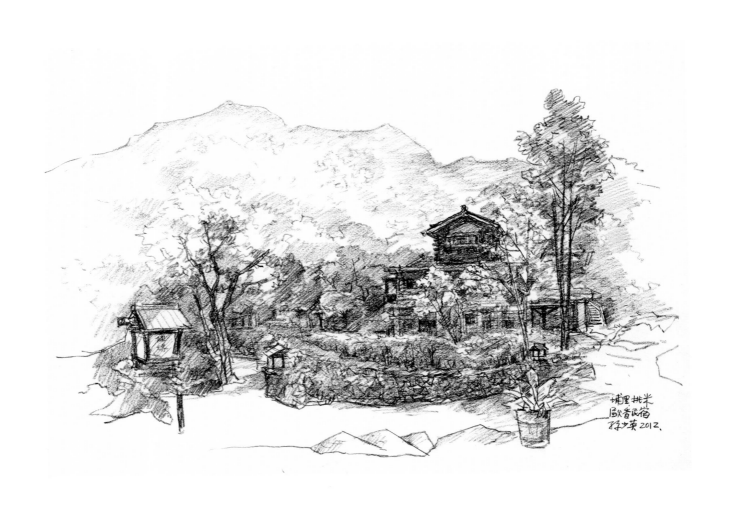

埔里桃米歐香民宿 2開 炭精筆 2012
Oushiang B&B at Taomi, Puli 2K Charcoal Pencil 2012

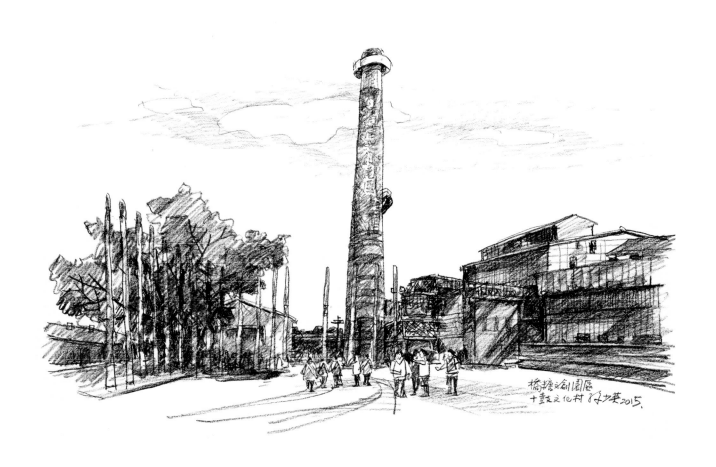

高雄橋糖文創園區 2開 炭精筆 2015
Ciaotou Creative Park, Kaohsiung 2K Charcoal Pencil 2015

簽字筆素描.

簽字筆固定是黑色，
沒有鉛筆或炭精
筆可依靠手的輕重
畫出黑白灰的調子，
但若能技巧的掌握
線條的疏密，仍
可畫出部份的深
灰和淺灰。

請參閱第14頁〈我追求的素描趣味〉一文

Marker Pen Sketch

The fixed color of the marker pen is black. Unlike pencils or charcoal pencils, it cannot generate tones of black, white and gray by manual strength. However, dexterous spacing of lines will master a certain degree of deep and shallow grayness.

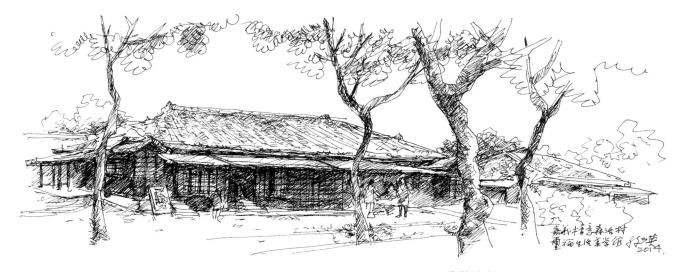

嘉義檜意森活村（一） 8開 簽字筆 2014
Hinoki Village, Chiayi (I) 8K Marker Pen 2014

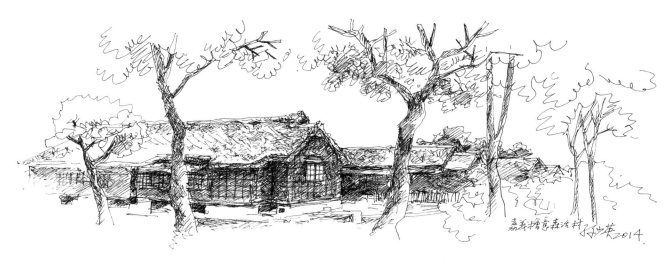

嘉義檜意森活村（二） 8開 簽字筆 2014
Hinoki Village, Chiayi (II) 8K Marker Pen 2014

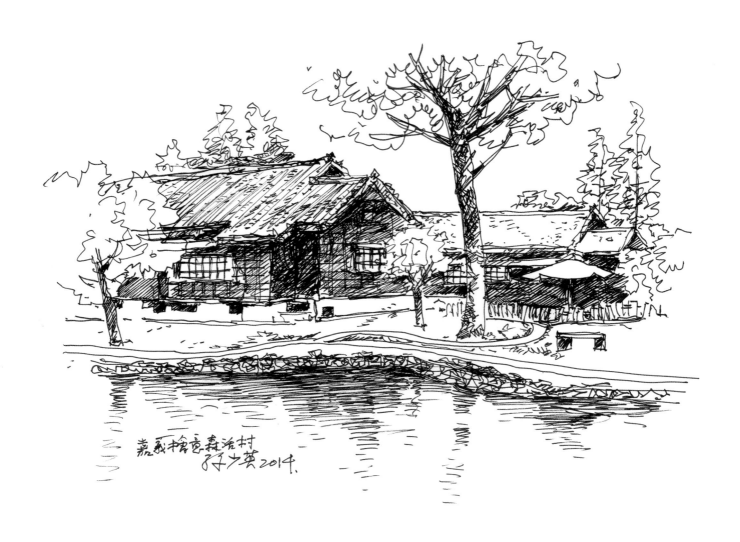

嘉義檜意森活村（三）　8開　簽字筆　2014
Hinoki Village, Chiayi (III)　8K　Marker Pen　2014

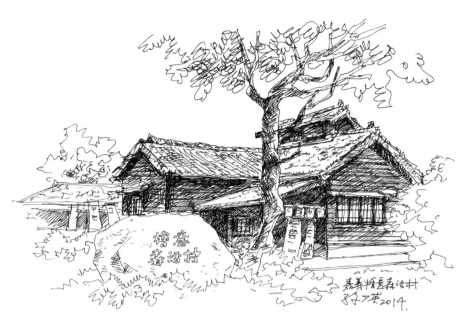

嘉義檜意森活村（四） 8開 簽字筆 2014
Hinoki Village, Chiayi (IV) 8K Marker Pen 2014

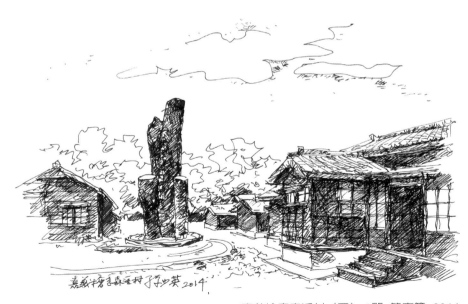

嘉義檜意森活村（五） 8開 簽字筆 2014
Hinoki Village, Chiayi (V) 8K Marker Pen 2014

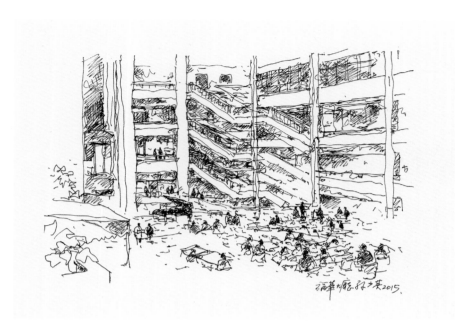

台北福華飯店大廳　8開　簽字筆　2015
Lobby at Howard Plaza Hotel, Taipei　8K　Marker Pen　2015

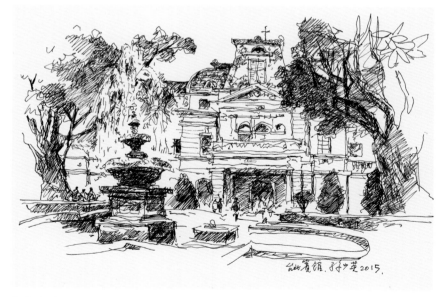

台北賓館　8開　簽字筆　2015
Taipei Guest House　8K　Marker Pen　2015

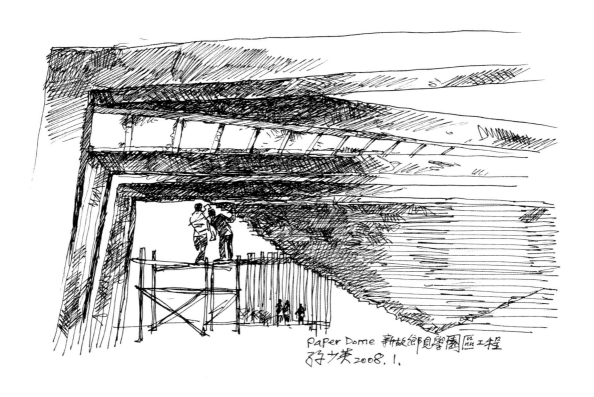

Paper Dome 新故鄉見學園區工程
符少英 2008. 1.

埔里新故鄉見學區工程　8開　簽字筆　2008
Construction of Newland Community Education Center, Puli　8K　Marker Pen　2008

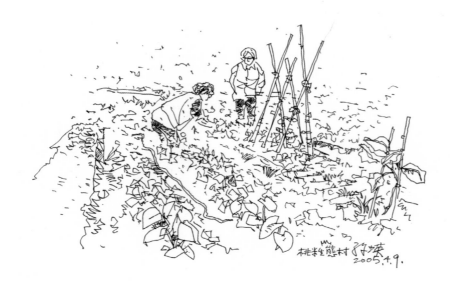

埔里桃米生態村　8開　簽字筆　2005

Taomi Eco-Village, Puli　8K　Marker Pen　2005

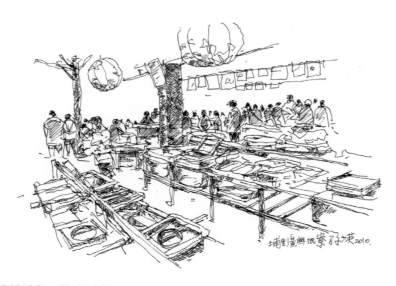

埔里廣興紙寮　8開　簽字筆　2010

Guangxing Paper Mill, Puli　8K　Marker Pen　2010

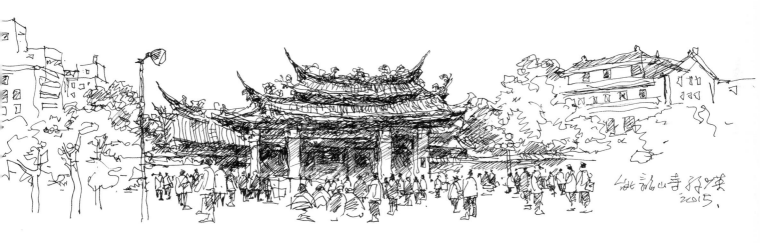

台北龍山寺　8開　簽字筆　2015
Longshan Temple, Taipei　8K　Marker Pen　2015

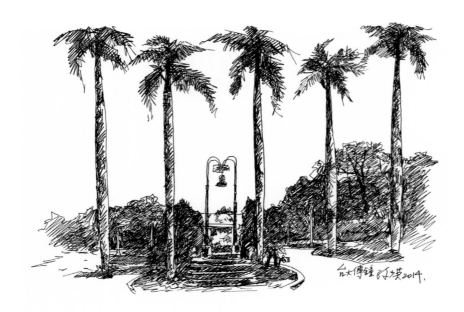

台大傅鐘　8開　簽字筆　2014

Fu Bell at National Taiwan University　8K　Marker Pen　2014

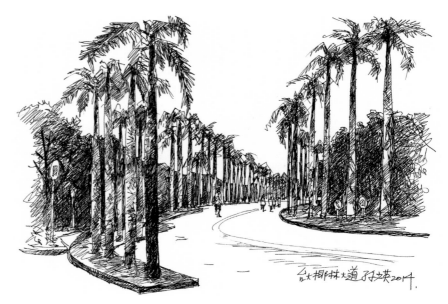

台大椰林大道　8開　簽字筆　2014

Coconut Tree Boulevard at National Taiwan University　8K　Marker Pen　2014

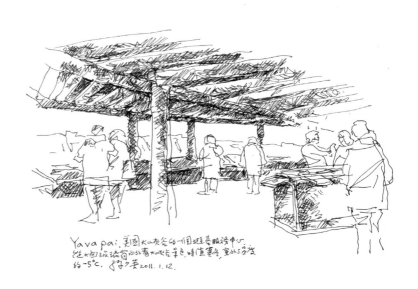

Yavapai: 美國大峽谷的一個遊客服務中心,
從大面玻璃窗向外看大峽谷景色,時值寒冬,室外近零度
約-5°C. 孟衣葉2011. 1. 12.

美國大峽谷遊客中心 8開 簽字筆 2011
The Grand Canyon Visitor Center, the U.S. 8K Marker Pen 2011

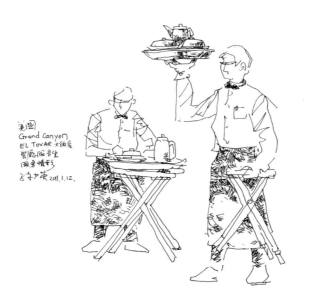

美國
Grand Canyon
EL TOVAR 大飯店
餐廳服務生
顧客情形
孟衣葉2011. 1. 12.

美國大峽谷餐廳服務生 8開 簽字筆 2011
Restaurant Waiters in Grand Canyon, the U.S. 8K Marker Pen 2011

二二八和平公園外看景色　8開　簽字筆淡彩　2015

Exterior View from the 228 Peace Memorial Park 8K Marker Pen-Outlined Wash Drawing 2015

台北市羅斯福路　8開　簽字筆淡彩　2014

Luosifu Road, Taipei 8K Marker Pen-Outlined Wash Drawing 2014

台北延吉街口 8開 簽字筆 2015
Entrance to Yanji Street, Taipei 8K Marker Pen 2015

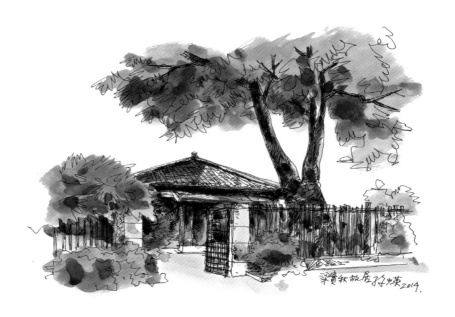

梁實秋故居 8開 簽字筆淡彩 2014
Liang Shih-Chiu's Former Residence 8K Marker Pen-Outlined Wash Drawing 2014

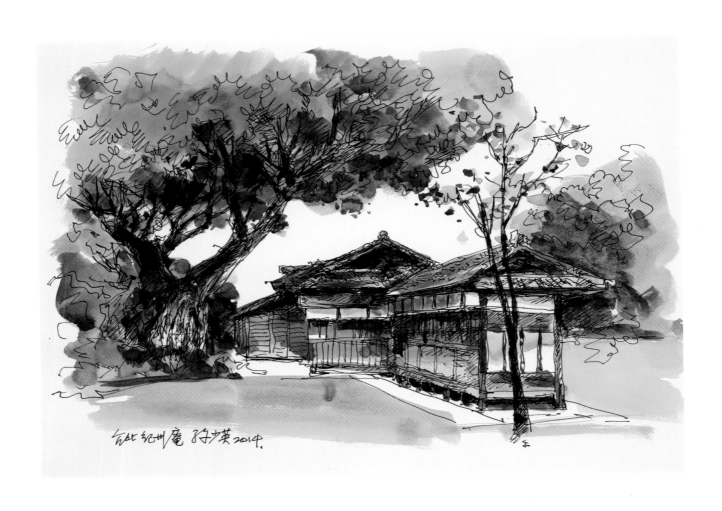

台北紀州庵（一） 8開　簽字筆淡彩　2014

Kishu An, Taipei (I) 8K Marker Pen-Outlined Wash Drawing 2014

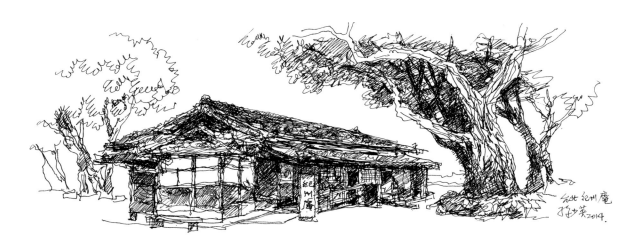

台北紀州庵（二） 8開 簽字筆 2014
Kishu An, Taipei (II) 8K Marker Pen 2014

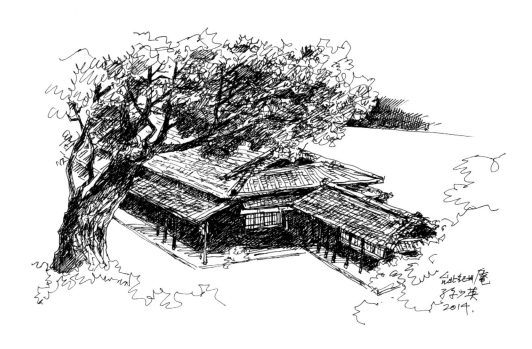

台北紀州庵（三） 8開 簽字筆 2014
Kishu An, Taipei (III) 8K Marker Pen 2014

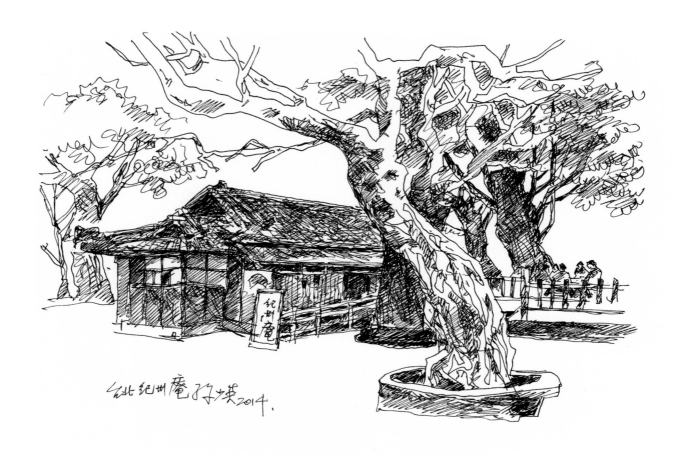

台北紀州庵（四） 8開 簽字筆 2014
Kishu An, Taipei (IV) 8K Marker Pen 2014

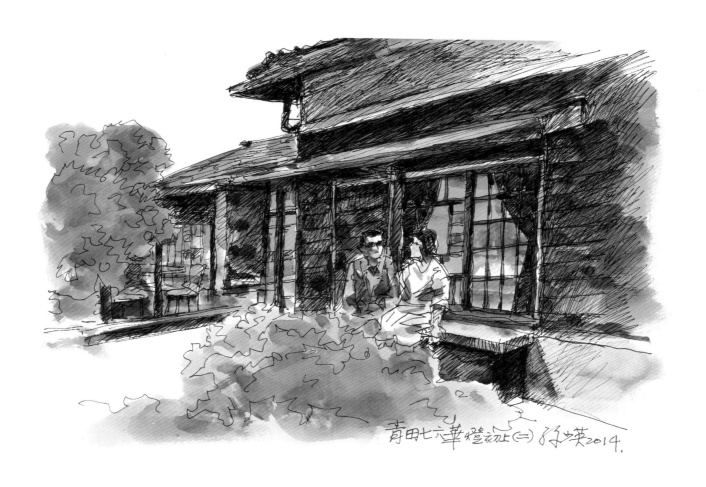

青田七六華燈初上（三）林英2014.

台北青田七六（一） 8開 簽字筆淡彩 2014
Qian Tian 76, Taipei (I) 8K Marker Pen-Outlined Wash Drawing 2014

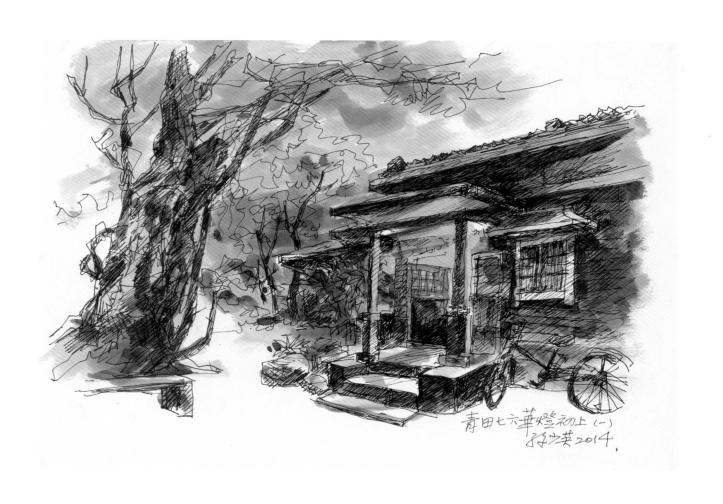

青田七六華燈初上（一）
林之英2014

台北青田七六（二） 8開 簽字筆淡彩 2014
Qian Tian 76, Taipei (II) 8K Marker Pen-Outlined Wash Drawing 2014

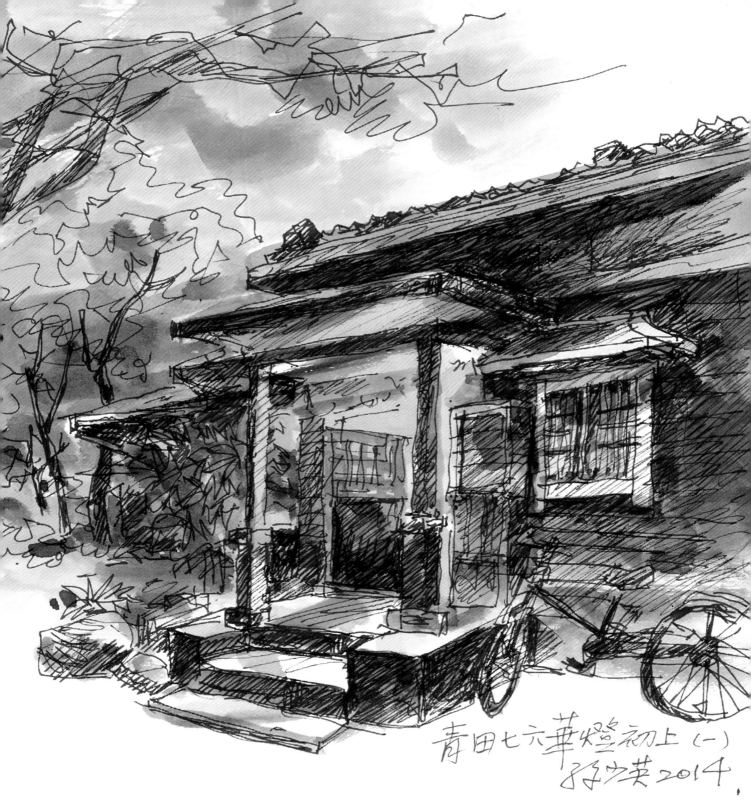

青田七六華燈初上（一）
郭O英 2014

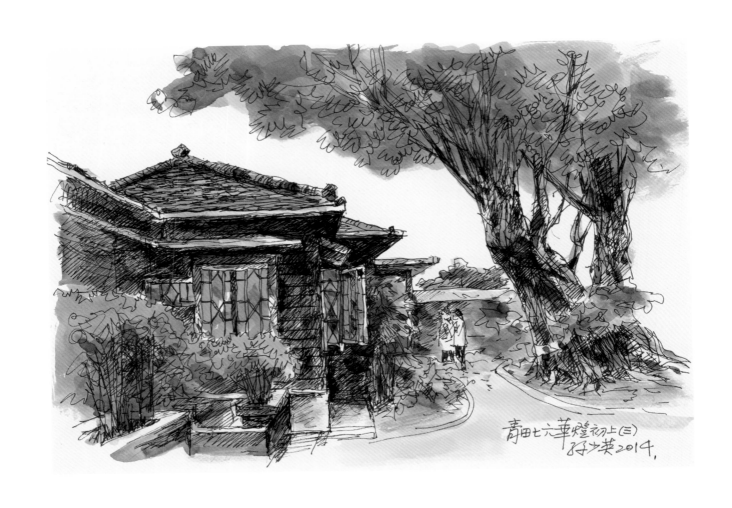

台北青田七六（三）　8開　簽字筆淡彩　2014
Qian Tian 76, Taipei (III)　8K　Marker Pen-Outlined Wash Drawing　2014

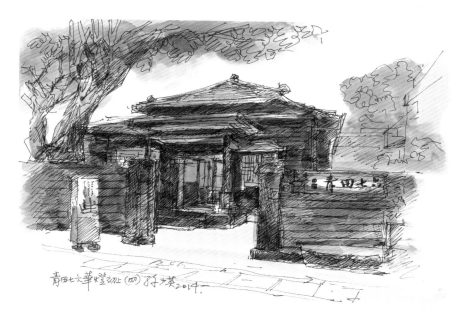

台北青田七六（四） 8開 簽字筆淡彩 2014
Qian Tian 76, Taipei (IV) 8K Marker Pen-Outlined Wash Drawing 2014

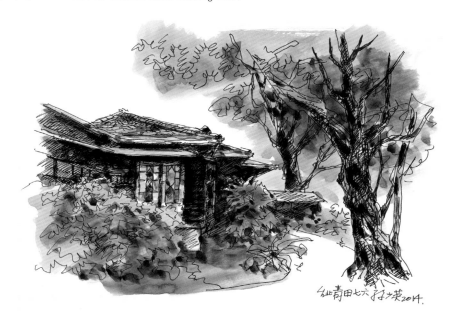

台北青田七六（五） 8開 簽字筆淡彩 2014
Qian Tian 76, Taipei (V) 8K Marker Pen-Outlined Wash Drawing 2014

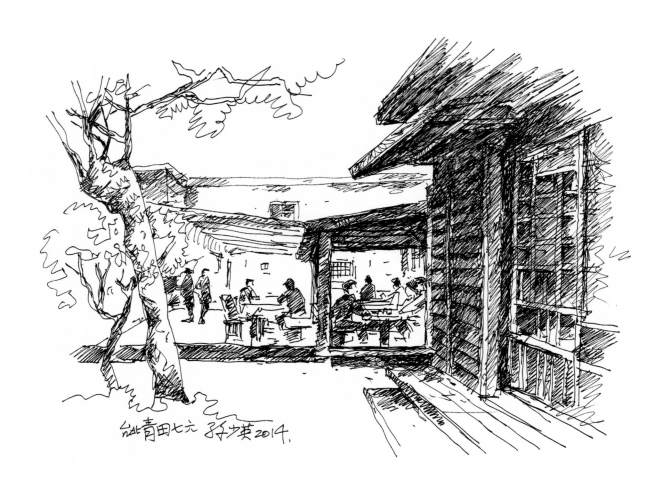

台北青田七六（六） 8開 簽字筆 2014
Qian Tian 76, Taipei (VI) 8K Marker Pen 2014

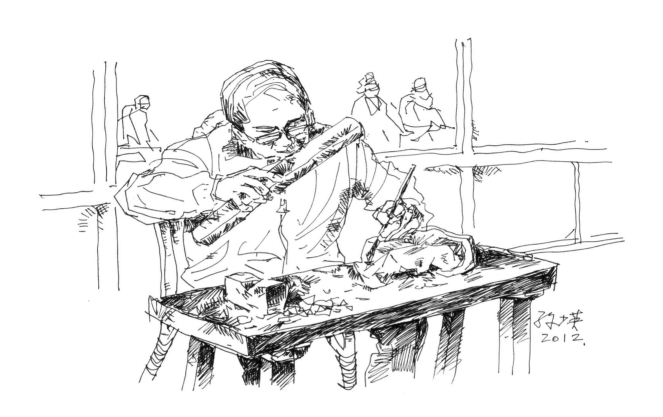

神像木雕師　8開　簽字筆　2012
Wood Sculptor 8K Marker Pen 2012

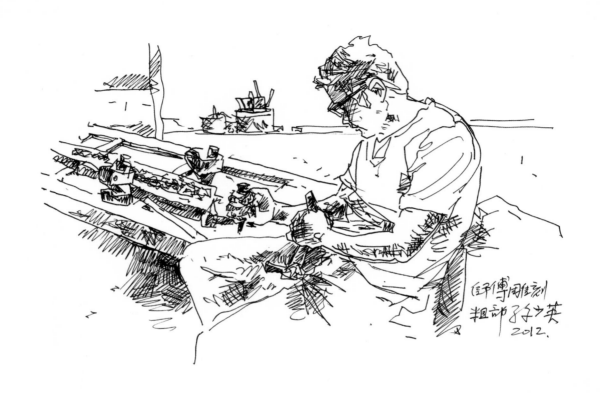

台南神轎雕刻師 8開 簽字筆 2012
Sculptor of Divine Sedan-Chair, Tainan 8K Marker Pen 2012

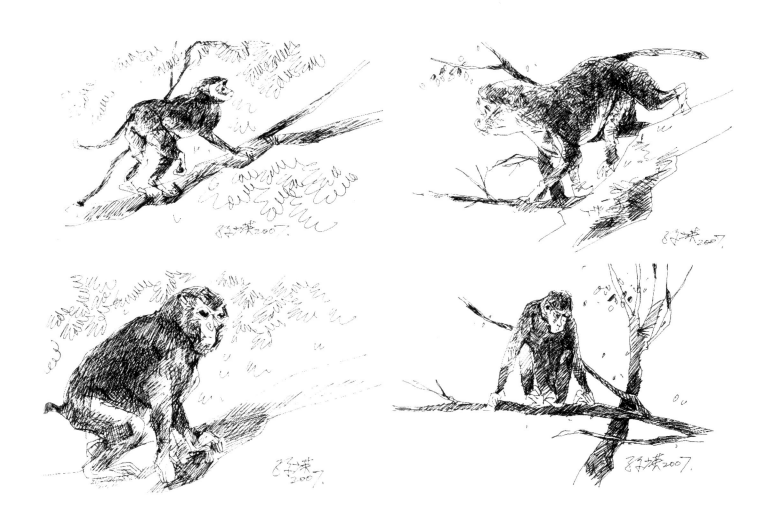

塔塔加台灣彌猴 8開 簽字筆 2007
Formosan Rock-Monkey, Tataka 8K Marker Pen 2007

墨筆賦彩

墨筆畫線條黑度够，
上彩濃一点對線條
沒有影响，可以重叠
上色，或儘量強调彩
度和明度跟一般
水彩畫的效果接近。

請參閱第14頁〈我追求的素描趣味〉一文

Ink Pen Coloring Sketch

While the lines are considerably black in ink paintings, it can hold darker colors without being affected. "Application of colors" means coloring in layers and emphasis on brightness and tonality, approaching the effects of watercolors.

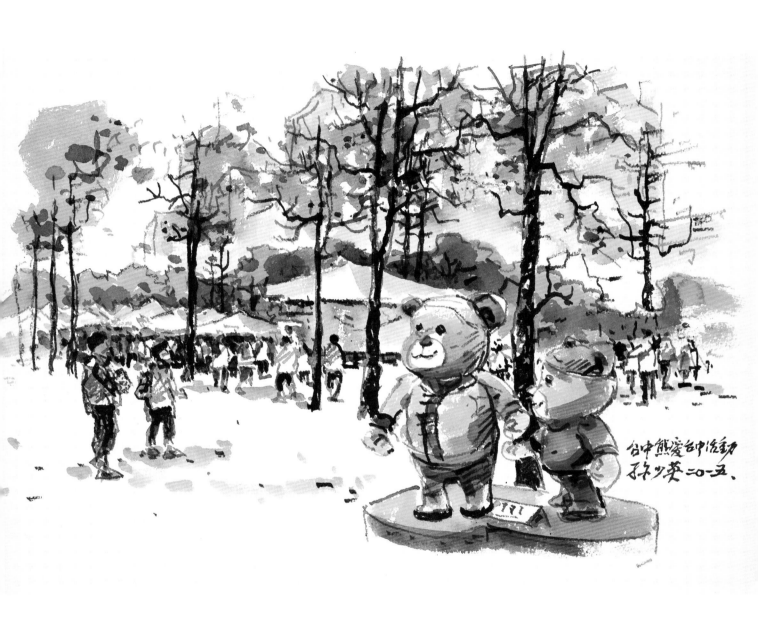

熊愛台中活動（一） 4開 墨筆賦彩 2015
Teddy Bear Lohas Carnival at Taichung (I) 4K Ink Pen Coloring 2015

熊愛台中活動（二）　4開　墨筆賦彩　2015
Teddy Bear Lohas Carnival at Taichung (II)　4K　Ink Pen Coloring　2015

熊愛台中活動（三）　4開　墨筆賦彩　2015
Teddy Bear Lohas Carnival at Taichung (III)　4K　Ink Pen Coloring　2015

熊愛台中活動（四） 4開 墨筆賦彩 2015
Teddy Bear Lohas Carnival at Taichung (IV) 4K Ink Pen Coloring 2015

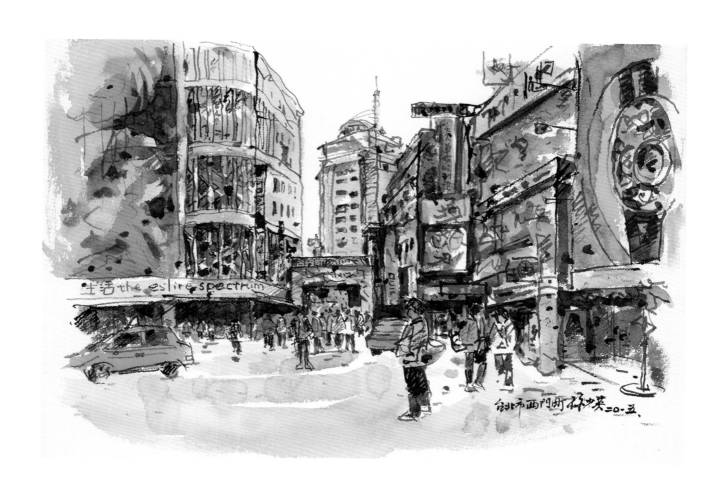

台北西門町（一） 4開 墨筆賦彩 2015
Ximending, Taipei (I) 4K Ink Pen Coloring 2015

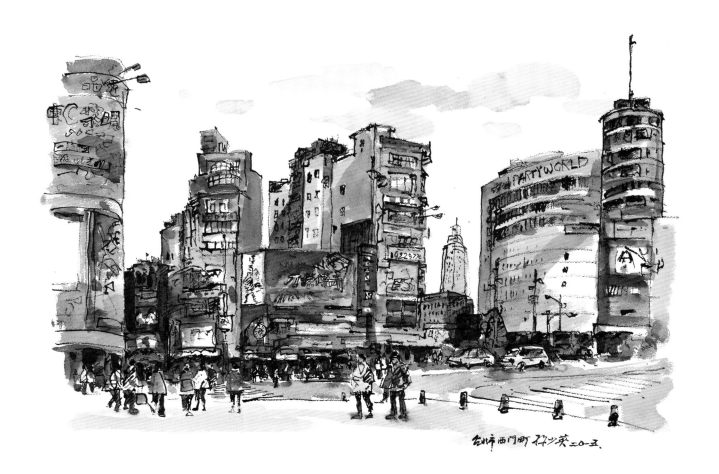

台北西門町（二） 2開 墨筆賦彩 2015
Ximending, Taipei (II) 2K Ink Pen Coloring 2015

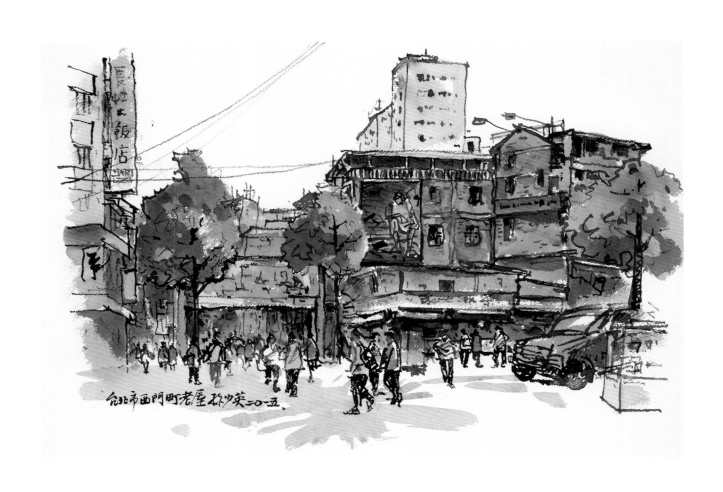

台北西門町（三） 4開　墨筆賦彩 2015
Ximending, Taipei (III)　4K　Ink Pen Coloring　2015

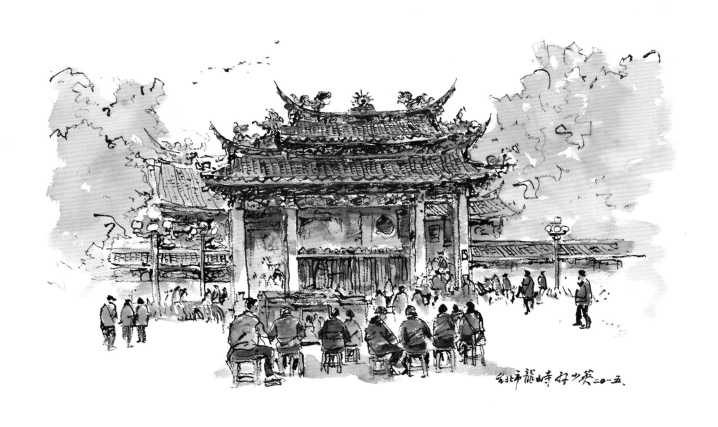

台北龍山寺 2開 墨筆賦彩 2015
Longshan Temple, Taipei 2K Ink Pen Coloring 2015

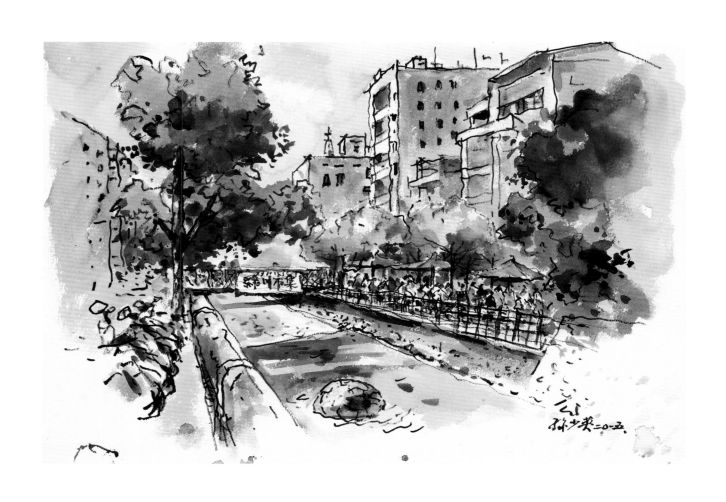

台中綠川市集　4開　墨筆賦彩　2015
Luchuan Market, Taichung　4K　Ink Pen Coloring　2015

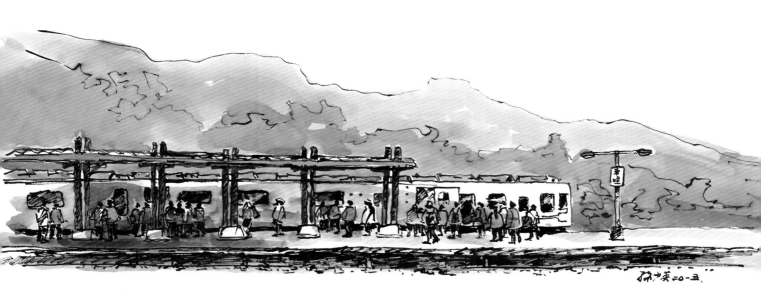

車埕車站　4開　墨筆賦彩　2015
Checcheng Station　4K　Ink Pen Coloring　2015

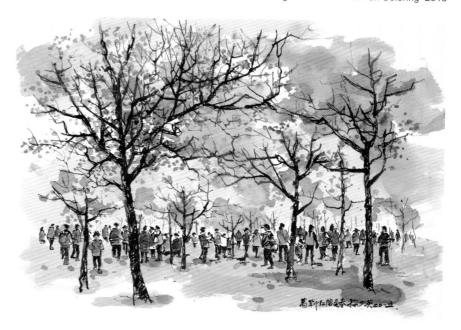

櫻花樹下　2開　墨筆賦彩　2015
Under the Cherry Trees　2K　Ink Pen Coloring　2015

畫畫不打稿 —早年台視新聞圖卡—

退休前,我在台視工作22年(1969〜1991),擔任美術指導和美術組長。

開始在新聞部工作,一段時間後調節目部。在新聞部工作性質相當於美編。那時候沒有電腦,後期有了電腦CBG2,性能不佳,對工作幫助不大,主要還是靠手繪。

新聞導播從總編輯處取得稿子,會分給美編一份,由美編根據稿子內容酌量配圖。

那時候配圖有兩類,一類是刊頭式的,記者在報一件新聞時,進影片前,記者要花約5秒時間報稿頭,即引進影片的一段文字,這段文字要配一張插圖,通常都是播映在記者的右上方,有提示影片內容的作用。這種插圖用的卡片叫Telop,大小比明信片小一點,是早期電視台標準用圖卡。美編插圖的位置,只有卡片右上方的四分之一,其他部位要留給播報記者。那時候我年紀輕,畫面雖小,不覺費力。

另一類插圖是解釋性的,有的新聞沒有影片和照片,是乾稿(只有文字的稿),美編要根據乾稿內容模擬性的畫一張插圖,配合播報,一方面是藉圖說明內容,一方面是使播出畫面有變化。

這兩類插圖,一節新聞大概要用十餘張,每張播出時間僅有3到5秒,一般觀眾看新聞對這些插圖大半不會留有印象,但對我們美編來說,每張小圖都是挑戰,第一要快,緊急時2〜3分鐘就要趕一張。第二要切題,切合新聞內容要點,絕不是抽象塗鴉。坦白說,這項工作還真是需要一點實力。所以那段時間養成了我畫畫不打草稿的習慣。

Painting Without Sketching —The Early News Cartoons for Taiwan Television—

Before my retirement, I had worked at Taiwan Television for 22 years from 1969 to 1991 as Art Director and Head of Art Department.

At the beginning I had worked at the News Division and then been transferred to the Program Division after a period of time. At that time, there was no computer, and later on the computer CBG2 had appeared but functioned ineffectively offering not much help for the job. We had mainly depended on drawings by hand.

The news program director received a script from general editors and distributed a copy to art editors who would match up illustrations for the news according to the script.

There were two kinds of illustrations at that time. The first kind was for the headline. When the journalist was broadcasting, reporting the headline would require five seconds before the news video. The headline was an introduction of the video comprising a paragraph of words and a cartoon, which was usually broadcasted on the journalist's upper right side functioning as a prompt for the news content. The card used for this kind of illustrations was called Telop, smaller than a regular postal card as a standard cartoon for the early television companies. The place for art editors to add the illustration was one quarter of the card on the upper right side, and the remaining space was reserved for the news reporter. Then I was young and had felt effortless to work on the fairly small picture.

The second kind of illustrations was explanatory. Some news came without videos or photos, which were dry scripts (words only). Art editors had to draw a cartoon to simulate the contents of the dry script to suit the broadcast. It served as an illustration to explain the contents and also a visual variation for the broadcast.

For the second kind of illustrations, a section of news would approximately require more than 10 cartoons. For each cartoon, there was merely three to five seconds of airing time. General audience would normally be unimpressed by these cartoons when watching news. But for us, art editors, each cartoon was a challenge. Firstly, we had to be quick and might have to finish one picture within two to three minutes in an emergency. Secondly, we had to be relevant to the subject; the picture had to be fit in with the gist of news, rather than a random one in abstraction. Frankly, this job had demanded certain substantial competence. Thus, I had cultivated my habit of painting without sketching during that period of time.

孫少英

一、學・經歷

1931　出生於中國山東省諸城縣。

1943　諸城縣瑞華小學畢業。

1946　膠縣瑞華中學肄業。（因戰亂輟學）

1949　青島市立李村師範學校肄業。

1949　隨兄長任職之部隊撤退到海南島。

1950　來到台灣。

1952　考取政工幹校藝術系。

1955　政工幹校畢業。

1961　自軍中退伍。

1961　服務於日月潭教師會館。
　　　對日月潭的湖光山色留下深刻印象，從此埋下了用水彩
　　　表現日月潭之美的願望。

1962　進入光啓社製作部負責電視教學節目製作及電視節目美
　　　術設計。
　　　當時光啓社是台灣唯一的電視節目製作專業機構，初創
　　　的台灣電視公司，許多節目都是由光啓社製作供應播出。

1963　出版了第一本畫冊－《孫少英鉛筆畫集》。

1964　在光啓社由製作部調到動畫部。
　　　動畫部負責人趙澤修在美國修習動畫製作，學成歸國，
　　　成立動畫部，其任內完成數部動畫短片，是台灣動漫藝
　　　術的濫觴。

1965 三年中利用假日到北投復興崗補修學分，取得復興崗
｜
1968 大學學士學位。

1969　考取台灣電視公司美術指導。

1985　升任美術組組長。

1986　到日本NHK及富士電視考察電視美術作業。
　　　同年到韓國KPS電視台訪問。

1987　爲台視建立電腦美術作業系統，是當時台灣電視事業的
　　　一大創舉。

1991　自台灣電視公司退休。
　　　同年移居埔里專事繪畫及寫作。
　　　（埔里爲妻翁水玉的家鄉）

1992　受邀參加「中華民國畫家訪問團」。
　　　訪問新加坡及馬來西亞，與當地畫家寫生交流。

1994　與畫家好友文霽到歐洲寫生。

1997　出版《從鉛筆到水彩》一書，此書爲初學素描及水彩的
　　　工具書，現已印行三版。

1998　出版《埔里情素描集》。

1999　九二一大地震，在災難中完成災況素描百餘幅，發表於
　　　各大報章雜誌。

2000　在誠品書局敦南店發表新書《九二一傷痕》素描集。
　　　這批素描原畫全部由九二一重建基金會收藏，之後捐贈
　　　予台大圖書館做爲紀念九二一大地震之永久典藏。

2001　受邀擔任全國大專院校繪畫比賽評審委員。

2001　出版震後重建圖文集《家園再造》。

2001　到廣西漓江寫生。

2002　佛光山刊物《人間福報》覺世副刊特闢〈孫少英圖文〉
　　　專欄，每週一篇，連續三年。

2002　第二次到廣西漓江寫生。

2002　受邀擔任全國公教人員繪畫比賽評審委員。

2003　接受日月潭國家風景區管理處委託，完成《水彩日月潭》
　　　專集，此爲風管處贈送貴賓之代表性禮品。七十幅水彩
　　　原畫，部份爲風管處收藏。

2003　受聘擔任彰化縣「磺溪」獎評審委員。

2004　受新故鄉文教基金會之邀，完成台灣社區營造水彩畫四
　　　十幅。之後又完成新故鄉見學園區紙教堂施工過程素描
　　　二十幅。

2005　受上旗出版社之邀，完成《畫家筆下的鄉居品味》一書。

2005　在誠品書局天母店舉辦新書《畫家筆下的鄉居品味》發
　　　表會。

2005　受聘爲埔里鎮圖書館第一屆駐館藝術家。

2005　接受天仁集團日月潭大淶閣飯店委託，繪製〈大淶閣景
　　　觀〉巨幅水彩畫。

2005　豐年社《鄉間小路》月刊闢〈孫少英畫我家園〉專欄，
　　　連載十年。

2005　到日本上高地賞楓寫生。

2006　發起創立埔里小鎮寫生隊，每年於埔里鎮田園藝廊舉辦
　　　聯展，對地方藝文推展很有貢獻。

2006　擬定「台灣系列」寫生計劃，預訂每年一書一展。

同年台灣系列（一）《日月潭環湖遊記》出版，是一本兼具旅遊導覽的畫冊。

2007 到蘇州和杭州西湖寫生。

2008 台灣系列（二）《阿里山遊記》出版。歷時一年，走遍阿里山遊樂區及四個鄉，往返十次才完成。

2009 台灣系列（三）《台灣小鎮》出版，選擇淡水、北埔、美濃等具有特色的十五個鄉鎮，全部實地寫生完成。

2009 到日本秋田縣賞櫻寫生。

2009 受邀擔任南投縣玉山獎評審委員。

2010 到美國加州和亞利桑那州寫生。

2010 台灣系列（四）《台灣離島》出版，台灣共有六個離島，還有許多附屬小島。搭機、坐船、爬山、涉水，在寫生過程中，相當費力勞神。

2011 台灣系列（五）《山水埔里》出版，充分展現家鄉之美。

2012 集美國、日本、中國大陸寫生畫作一百二十幅，出版《寫生散記》。

2013 台灣系列（六）《台灣傳統手藝》出版，藉以對台灣民間身懷絕技的老師傅們表達至誠敬意。

2013 受天福集團委託完成120cm×420cm巨幅水彩畫〈台灣日月潭覽勝〉，現典藏於中國北京。

2013 受盧安藝術文化有限公司委託，繪製《水之湄—日月潭水彩畫記》。

2014 受邀擔任南投縣玉山獎評審委員。

2014 受盧安藝術文化有限公司委託，繪製《荷風蘭韻》。

2014 受學學文創基金會之邀，精選五十張畫作，置入「學學台灣文化色彩」網站之「靈感圖庫」中，供藝術及設計者學習色彩的應用。

2014 與盧安藝術文化有限公司共同議定「藝術傳承」計劃。

2014 「藝術傳承1」台灣大專院校校園贈《水之湄—日月潭水彩畫記》活動。

2014 「藝術傳承2」快樂寫生日—每月推廣戶外寫生活動。

2014 《荷風蘭韻》新書出版。

2014 「藝術傳承3」台灣美術班系校園示範活動。

二、畫歷

（一）個人展覽

1976 台北市美國新聞處林肯中心素描個展。

1978 台北市龍門畫廊水彩個展。

1980 台灣省立博物館水彩個展。

1982 台北來來藝術水彩個展。

1989 台北黎明藝文中心水彩個展。

1990 台北黎明藝文中心水彩個展。

1992 雲林縣立文化中心水彩個展。

1993 台南市省立社教館水彩個展。

1993 台南市國策藝術中心水彩個展。

1996 埔里鎮牛耳藝術公園藝廊水彩個展。

1997 台中縣絲寶展示廳水彩個展。

1997 埔里鎮藝文中心田園藝廊水彩個展每年舉辦一次

2012 連續六年。

1998 埔里鎮牛耳藝站素描個展。

1998 埔里基督教醫院藝廊水彩個展。

1999 台南市省立社教館邀請展。

2000 埔里鎮金鶯山藝文天地水彩個展。

2001 埔里鎮金鶯山藝文天地水彩個展。

2005 台中市文化中心水彩個展。

2006 彰化縣文化中心水彩個展。

2007 新竹市文化中心水彩個展。

2007 高雄市文化中心水彩個展。

2011 埔里鎮鴨子咖啡藝廊水彩個展。

2012 埔里鎮鴨子咖啡藝廊素描個展。

2013 南投縣縣政府文化局邀請玉山畫廊水彩個展。

2013 台中市咸亨堂畫廊水彩個展。

2013 台中文創園區「水之湄」日月潭水彩畫展。

2014 嘉義市檜意森活村「美哉阿里山」個展。

2014 台北福華沙龍「荷風蘭韻」個展。

2014 台中咸亨堂畫廊、盧安小畫廊、喜佳美飯店「綻放台中情」三聯展。

2014 高雄文化中心「水湄荷風」巡迴展（一）。

2014 南投縣藝術家資料館「水湄荷風」巡迴展（二）。

2015　受禾碩建設委託為「墨花香」新建案，完成多
　　　媒材素描創作的專題。
2015　台北禾碩建築「墨花香」個展。
2015　受盧安藝術文化有限公司委託，繪製《素描趣
　　　味》。
2015　台中盧安小畫廊「春趣‧三月天」常態展。
2015　台中大墩文化中心「意在‧台中」水彩個展。
2015　台中盧安小畫廊「夏日‧悠遊」常態展。
2015　台北福華沙龍「從素描到水彩」孫少英個展。

（二）重要聯展
歷屆全國美展邀請展
亞洲水彩畫家聯盟展
台北市立美術館開館邀請聯展
台灣省立美術館開館邀請聯展
台南市舉辦千人美展
高雄市舉辦當代美術大展
國立歷史館邀請聯展
國立藝術館四季美展
中國美術協會歷年聯展
中華民國藝術訪問團東南亞巡迴展
中國水彩畫會各縣市文化中心巡迴展
海峽兩岸水彩聯展
台南市社教館舉辦當代畫家百人展
台南市社教館舉辦全國名家水彩聯展
彰化縣磺溪獎評審邀請展
台中市及文化中心舉辦全國水彩畫展
台南市社教館舉辦全國書畫大展
國立台灣藝術教育館舉辦兔年特展
中興大學主辦水彩名家聯展
台灣國際水彩畫會歷年聯展
南投市歷年玉山獎邀請展

（三）參加藝文社團
中國美術協會
中國文藝協會
中國水彩畫會
台灣國際水彩畫協會
南投美術協會
中國當代藝術協會
投緣水彩畫會
藝池畫會
埔里小鎮寫生隊
埔里鎮立圖書館第一屆駐館藝術家

（四）獎項
台北市金橋獎座設計首獎
台灣文藝協會水彩畫首獎

三、著作

《孫少英鉛筆畫集》
《從鉛筆到水彩》
《埔里情素描集》
《九二一傷痕素描集》
《家園再造寫生集》
《水彩日月潭》
《畫家筆下的鄉居品味》
《日月潭環湖遊記》
《阿里山遊記》
《台灣小鎮》
《台灣離島》
《山水埔里》
《寫生散記》
《台灣傳統手藝》
《水之湄—日月潭水彩畫記》
《荷風蘭韻》
《素描趣味》

Resume of **Sun Shao-Ying**

Resume of Author

1931 Born in Zhucheng County, Shandong Province, China.

1943 Graduated from Ruihua Elementary School of Zhucheng County.

1946 Incomplete study from Ruihua Middle School of Jiao County (in the turmoil of war).

1949 Incomplete study from Qindao Municipal Licun Normal School.

1949 Retreated to Hainan Island with the troop his elder brother served.

1950 Arrived in Taiwan.

1952 Admitted to Department of Arts, Political Staff School.

1955 Graduated from Political Staff School.

1961 Retired from military service.

1961 Employed by Sun Moon Lake Teacher's Hostel.Highly impressed by the lake and mountain scenery of Sun Moon Lake, imprinting a wish to express the beauty of Sun Moon Lake by watercolor on his mind ever since.

1962 Employed by Production Department of Guangchi Program Service to be in charge of producing TV teaching programs and artistic design. At that time, Guangchi Program Service was the only specialized TV production institute in Taiwan, producing many programs to supply the newly founded Taiwan Television Company.

1963 Published the first album- *Pencil Drawings of Sun Shao-Ying*.

1964 Transferred from Production Department to Animation Department at Guangchi Program Service.
The head of Animation Dept. Chao Tse-hsui founded the Animation Department after finishing his study of animation production in the U.S. and returned to Taiwan. During his tenure, he completed several animations which were deemed the start of animation art in Taiwan.

1965 During three years, he spent holidays to get make-up credits at

1968 Fuxingang, Beitou and received the Bachelor's degree of Fuxingang University.

1969 Qualified as Art Director, Taiwan Television.

1985 Promoted to the Head of Art Department.

1986 Inspected TV art direction at NHK and Fuji Television in Japan and visited KPS TV in Korea.

1987 Established the digital art operative system for TTV, which was a pioneering work for TV industry of Taiwan at that time.

1991 Retired from Taiwan Television and moved to Puli solely for painting and writing. (Puli is the hometown of his wife, Weng Shui-yu.)

1992 Invited to join the Delegation of ROC Painters to visit Singapore and Malaysia interacting with local painters by nature drawing.

1994 Visited Europe for nature drawing with a good friend, painter Wen Chi.

1997 Published the album, *From Pencil to Watercolor*, which is a reference book for beginners in sketching and watercolor, and now its third edition is in print.

1998 Published *Sketches of Puli*.

1999 After 921 Earthquake, finished more than a hundred sketches of disaster scenes during the calamity, which were presented on all major newspapers and magazines.

2000 Presented the new album, *The Scars of 921*, at Eslite Bookstore Dunnan Branch. The original sketches were all collected by 921 Earthquake Relief Foundation and then donated to National Taiwan University Library as permanent collection in memory of 921 Earthquake.

2001 Invited to act as Juror for National College Painting Competition.

2001 Published the album for the after-quake reconstruction, *Rebuilding Our Homeland*.

2001 Visited Lijiang, Guangxi for nature drawing.

2002 The publication of Fo Guang Shan, *Merit Times*, opened a special column of "Illustrated Essay of Sun Shao-Ying" in its "Awakening" supplement, presenting one article per week and continuing for three consecutive years.

2002 Visited Lijiang, Guangxi for nature drawing for the second time.

2002 Invited to act as Juror for National Painting Competition for Government Employees and Teachers.

2003 Commissioned by Sun Moon Lake National Scenic Area Administration and completed the album, *Watercolors of Sun Moon Lake*, as a representative gift for honorable guests. There were 70 original watercolors, some of which were collected by Scenic Area Administration.

2003 Invited to act as Juror for Huangxi Award of Changhua County.

2004 Invited by New Homeland Foundation to complete 40 watercolors on Community Building in Taiwan. Later, also finished 20 sketches on the construction process of Paper Dome at New Homeland Resource Park.

2005 Invited by Sun Kids Publishing to complete the book, *Country Life by Painter's Brushwork*.

2005 Held a new book release presentation for *Country Life by Painter's Brushwork* at Eslite Bookstore Tianmu Branch.

2005 Invited to be the first-term artist-in-residence for Puli Township Library.

2005 Commissioned by Sun Moon Lake Del Lago Hotel of Ten Ren Group to paint a large-canvas watercolor, *View of Del Lago*.

2005 *Country Road Monthly* of Harvest Farm Magazine opened a special column of "Sun Shao-Ying Painted My Homeland" which has run for 10 years by now.

2005 Visited Kamikochi in Japan to appreciate maples and draw from nature.

2006 Founded the Puli Painting Group to annually organize joint exhibits at Field Gallery of Puli, greatly contributing to the development of local arts and culture.

2006 Made a plan for nature painting on Taiwan Series, deciding on releasing one book and one exhibition every year. Published the first of Taiwan Series, *Round Trip of Sun Moon Lake*, which is an album and also tour guidebook.

2007 Visited Suzhou and West Lake (Xi Hu) of Hangzhou for nature painting.

2008 Published the second of Taiwan Series, *Scenic Jouney of Alishan*, after spending one year to walk all over Alishan Scenic Area and four townships on 10 round trips.

2009 Published the third of Taiwan Series, *Taiwan Townships*, choosing 15 distinctive townships such as Danshui, Beipu and Meinong to finish nature paintings on the spot.

2009 Visited Akitafan in Japan to appreciate cherry blossoms and draw from nature.

2009 Invited to act as Juror for Yushan Award of Nantou County.

2010 Visited California and Arizona of the U.S. for nature painting.

2010 Published the fourth of Taiwan Series, *Off-shore Islands of Taiwan*, after a taxing and strenuous process of nature painting via flights, boating, mountaineering and wades as Taiwan possesses six off-shore islands and many affiliated small islands.

2011 Published the fifth of Taiwan Series, *Landscape of Puli*, fully representing the beauty of homeland.

2012 Compiled 120 works of nature painting done in the U.S., Japan and Mainland China and published *Notes on Nature Painting*.

2013 Published the sixth of Taiwan series, *Traditional Arts of Taiwan*, in order to pay tribute to the masterfully skilled old craftsmen of Taiwan.

2013 Commissioned by Ten Fu Group to complete a huge canvas of watercolor by 420cmx120cm, *Beautiful Scenic Spots of Taiwan's Sun Moon Lake*, which is now in a collection in Beijing, China.

2013 Commissioned by Luan Art Co. Ltd. to paint for the album, *Searching for Beauty*.

2014 Invited to act as Juror of Yushan Award of Nantou County.

2014 Commissioned by the Luan Art Co., Ltd. to paint and compile the book, *Lotus Breeze Orchid Melody*.

2014 Invited by Xue Xue Foundation to select 50 paintings for the Collections in the website, Xue Xue Colors, offering the artists and designers examples to study the application of colors.

2014 Agreed on the plan of Legacy Art with Luan Art Co., Ltd.

2014 Held the activity of Legacy Art I to donate the book, *Searching for Beauty: Sun Moon Lake Watercolor Journal*, to Taiwan's colleges on campus.

2014 Began the monthly activity of Legacy Art II: A Happy Day of Drawing- to promote outdoor drawing.

2014 Published *Lotus Breeze Orchid Melody*.

2014 Held the activity of Legacy Art III to give a live demonstration on campus for Taiwan's art departments.

Exhibit Experience

1. Solo Exhibitions

1976 Drawing Solo Exhibition at Lincoln Center of United States Information Service, Taipei City

1978 Watercolor Solo Exhibition at Longman Gallery, Taipei City

1980 Watercolor Solo Exhibition at Taiwan Provincial Museum

1982 Watercolor Solo Exhibition at Lailai Gallery, Taipei

1989 Watercolor Solo Exhibition at Liming Arts and Culture Center, Taipei

1990 Watercolor Solo Exhibition at Liming Arts and Culture Center, Taipei

1992 Watercolor Solo Exhibition at Yunlin County Cultural Center

1993 Watercolor Solo Exhibition at Provincial Social and Education Hall,Tainan

1996 Watercolor Solo Exhibition at New Era Art Park Gallery, Puli Township

1997 Watercolor Solo Exhibition at Sibao Exhibition Hall, Taichung County

1997 Watercolor Solo Exhibition at Pastoral Gallery, Puli Art Center,

2012 annually for 6 consecutive years

1998 Drawing Solo Exhibition at New Era Art Station, Puli Township

1998 Watercolor Solo Exhibition at Puli Christian Hospital Gallery

1999 Invitation Exhibition at Provincial Social and Education Hall, Tainan City

2000 Watercolor Solo Exhibition at Jingyingshan Art Center, Puli Township

2001 Watercolor Solo Exhibition at Jingyingshan Art Center, Puli Township

2005 Watercolor Solo Exhibition at Taichung City Cultural Center

2006 Watercolor Solo Exhibition at Changhua County Cultural Center

2007 Watercolor Solo Exhibition at Hsinchu City Cultural Center

2007 Watercolor Solo Exhibition at Kaohsiung City Cultural Center

2011 Watercolor Solo Exhibition at Arts Café Gallery, Puli Township

2012 Drawing Solo Exhibition at Arts Café Gallery, Puli Township

2013 Watercolor Solo Exhibition at Yushan Gallery, invited by Nantou County

2013 Watercolor Solo Exhibition at Xianhengtang Gallery, Taichung City

2013 Searching for Beauty: Sun Moon Lake Watercolor Exhibition at Taichung Cultural and Creative Industries Park

2014 Beautiful Alishan: Solo Exhibition at Hinoki Village, Chiayi City

2014 Lotus Breeze Orchid Melody: Solo Exhibition at Howard Salon, Taipei

2014 Blooming Taichung: Joint Exhibition of Xianheng Gallery, Luan Art Gallery and Sicame Hotel, Taichung

2014 Waterfront Lotus in a Breeze: Tour Exhibition I at Kaohsiung Cultural Center

2014 Waterfront Lotus in a Breeze: Tour Exhibition II at Cultural Affairs Bureau, Nantou County

2015 Commissioned by Harvest Construction to complete a special work of multimedia sketching for the new construction project, Floral Fragrance in Ink

2015 Floral Fragrance in Ink: Solo Exhibition at Harvest Construction, Taipei

2015 Commissioned by the Luan Art Co., Ltd. to draw and compile the book, *Sketching Delights*

2015 Spring Flavor in March: Regular Exhibition at Luan Art Gallery, Taichung

2015 Longing for Taichung: Watercolor Solo Exhibition at Dadun Cultural Center, Taichung

2015 Summer Leisure: Regular Exhibition at Luan Art Gallery, Taichung

2015 From Pencil to Watercolor: Solo Exhibition at Howard Salon, Taipei

2. Important Joint Exhibitions

· Invitation Exhibition at National Art Exhibition of the Republic of China, all the sessions
· Asia Watercolor Painting Alliance Exhibition
· Invited Group Exhibition for the Opening of Taipei Fine Arts Museum
· Invited Group Exhibition for the Opening of Provincial Fine Arts Museum of Taiwan
· Thousand-People Art Exhibition, held by Tainan City
· Contemporary Art Exhibition, held by Kaohsiung City
· Invited Group Exhibition at Nation History Museum
· Four Season Art Exhibition at National Center of Arts
· Group Exhibition of China Art Association, through the years
· Southeast Asia Tour Exhibition of R.O.C. Art Delegation
· Tour Exhibition of China Watercolor Association around County/City Cultural Center
· Cross-Strait Joint Exhibition of Watercolor
· Contemporary Hundred-People Painter Exhibition, held by Tainan City Social Education Hall
· Joint Exhibition of Domestic Renowned Watercolor Painters, held by Tainan City Social Education Hall
· Jury Invitation Exhibition of Huangxi Award of Changhua County
· National Watercolor Exhibition, held by Taichung City and Cultural Center

· National Calligraphy and Painting Exhibition, held by Tainan City Social Education Hall
· Year of the Rabbit Special Exhibition, held by National Taiwan Arts Education Center
· Joined Exhibition of Renowned Painters, held by National Chung Hsing University
· Joint Exhibition of International Association of Watercolor Taiwan, through the years
· Invitation Exhibition for Yushan Award of Nantou City, through the years

3. Arts and Culture Association

· China Art Association
· China Literature and Art Association
· China Watercolor Association
· International Association of Watercolor Taiwan
· Nantou Art Association
· China Contemporary Association
· Affinity Watercolor Society
· Art Pool Painting Society
· Puli Painting Group
· First-term Artist-in-Residence of Puli Township Library

4. Awards

· First Place in Design of Golden Bridge Award, Taipei City
· First Place in Watercolor, Taiwan Literature and Art Association

Publication

· *Pencil Drawings of Sun Shao-Ying*
· *From Pencil to Watercolor*
· *Sketches of Puli*
· *The Scars of 921*
· *Rebuilding Our Homeland*
· *Watercolors of Sun Moon Lake*
· *Country Life by Painter's Brushwork*
· *Round Trip of Sun Moon Lake*
· *Scenic Journey of Alishan*
· *Taiwan Townships*
· *Off-shore Islands of Taiwan*
· *Landscape of Puli*
· *Notes on Nature Painting*
· *Traditional Arts of Taiwan*
· *Searching for Beauty*
· *Lotus Breeze Orchid Melody*
· *Sketching Delights*

國家圖書館出版品預行編目資料

素描趣味 / 孫少英作. -- 臺中市：盧安藝術
文化, 民104.07
144面；21×22.5公分
ISBN 978-986-89268-3-7（平裝）

1.素描　2.畫冊

947.16　　　　　　　　　　104012292

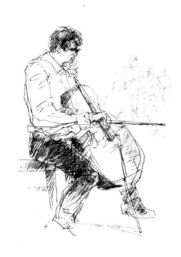

孫少英的

素描趣味
Sketching Delights

作　　　者：孫少英	Author: Sun Shao-Ying	
發 行 人：盧錫民	Publisher: Lu Hsi-Ming	
總 策 劃：康翠敏	Planner: Kang Tsui-Min	
英文翻譯：李若薇	English Translator: Ruby J. Lee	
英文校對：朱侃如	English Modification Proofreader: Chu Kan-Ju	
文字校對：廖英君	Chinese Modification Proofreader: Liao Ying-Chun	
出版單位：盧安藝術文化有限公司	Published by: Luan Art Co., Ltd.	
郵政劃撥帳號：22764217	Postal Transfer A/C: 22764217	
地址：403台中市西區台灣大道2段375號11樓之2	Address: 11F.-2, No.375, Sec. 2, Taiwan Blvd., West Dist., Taichung City 403, Taiwan (R.O.C.)	
電話：04-23263928	TEL: 04-23263928	
E-mail：luantrueart@gmail.com	E-mail：luantrueart@gmail.com	
官　　網：www.luan.com.tw	Website: www.luan.com.tw	
設計印刷：立夏文化事業有限公司	Limited Company of Cultural Undertakings of the Beginning of Summer	
地址：412台中市大里區三興街1號	Address: No.1, Sanxing St., Dali Dist., Taichung City 412, Taiwan (R.O.C.)	
電話：04-24065020	TEL: 04-24065020	
出版：中華民國104年7月	Publish Date: July 2015	
定價：新臺幣1200元	Price：NT$1200	

ISBN　978-986-89268-3-7